TONY EVANS TAKING HIS TIME

TONY EVANS

TAKING HIS TIME

Booth-Clibborn

Editions

Edited by David Gibbs,
David Hillman and Caroline Edwards

Taking His Time has been compiled to coincide with the retrospective exhibition of Tony Evans's work, which is opening at the Djanogly Art Gallery, Nottingham, in February 1998 and subsequently travelling to other venues.

Exhibition
Selected by David Hillman
and Caroline Edwards
Organised by Joanne Wright
and Caroline Edwards
Designed by David Hillman

Catalogue
Edited by David Gibbs,
David Hillman and Caroline Edwards
Designed by David Hillman and
Deborah Osborne
Printed and bound in Hong Kong

Published by Booth-Clibborn
Editions
12 Percy Street, London W1P 9FB
info@internos.co.uk
www.booth-clibborn-editions.co.uk

ISBN 1 861540 12 4

Contents

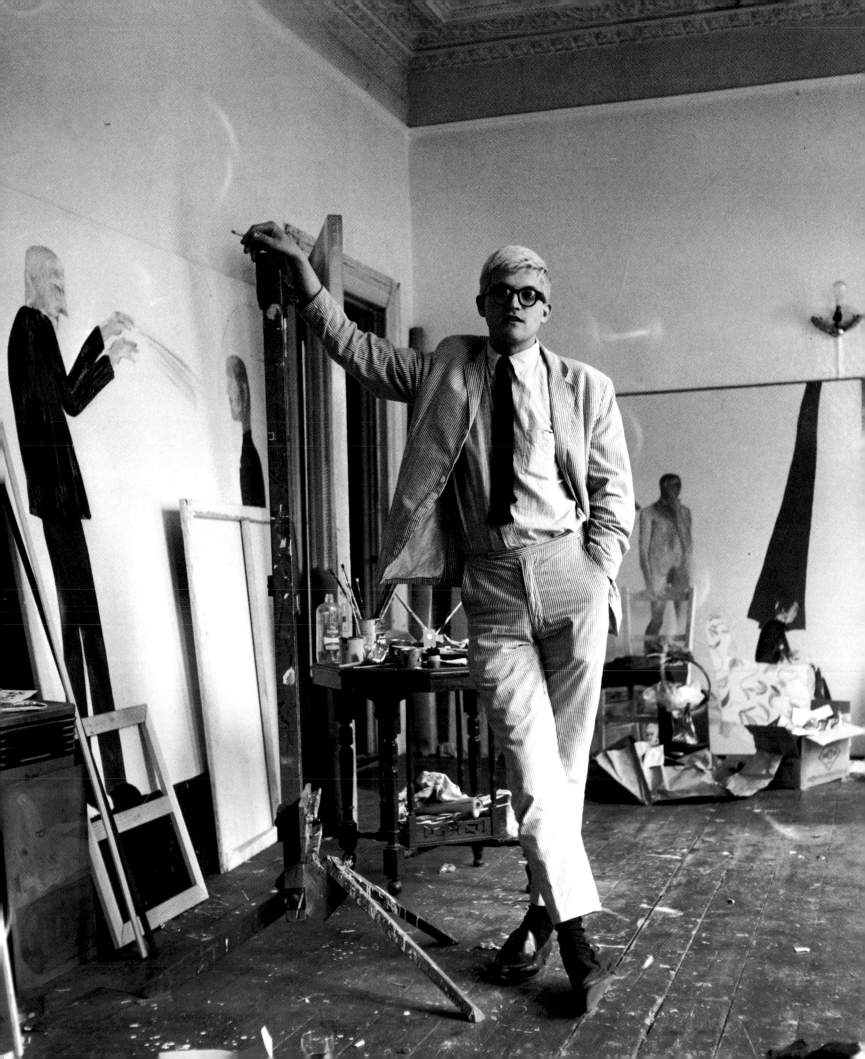

Bruce Bernard was Picture Editor at the *Sunday Times Magazine* from 1972 to 1980, and for some time visual arts editor of the *Independent Saturday Magazine*. He has compiled several books on photography and art, and is currently working on a 750-page history of the 20th century in photographs.

Tony Evans

by Bruce Bernard

As a photographer for hire, Tony Evans was surely a unique one, and more than worthy of this celebration, as well as his place in the creative memories of his successors, associates – and of those just interested in excellence. Most of his work was in the public domains of advertising and editorial illustration, and also the comforting British tea-table books, which avoid as is their right and purpose, all the less pleasant aspects of life, but to which he brought an extra depth and beauty. Surely his unique artistic character, which was composed of obsessive perfectionism, ingenuity and devotion to the visible world as he chose to edit it for the camera, will simply never be seen again – whatever awaits us in the way of photographic talent.

I have generally thought (and on the whole still do) that a photograph in which everything has been observed and brought under control must lack some kind of vitality. I once heard André Kertesz (capable of great photographic precision) vehemently denounce the 'f64' school – Weston, Ansel Adams and their followers – and I had to agree with him. To make the camera into a 'perfect' kind of eye seemed inhuman and therefore all wrong to me. At first I thought Tony might be of this persuasion but on looking further at his work I found that this was not at all the whole story, and *The Flowering Britain* entirely refutes the notion. It was also true that a photographer who tested each batch of Kodachrome before he would work with it, and send it for processing only on Tuesday afternoons – or whenever he thought the chemicals were at their most reliable – inspired little empathy with me. But after all, the Flemish Primitive painters of the fourteenth century had to be more fastidious about their materials than the Impressionists, who, because of their far thicker application in their case had no need to be quite so fussy about pigments and medium. Tony's twentieth-century fussiness was not blindly obsessional, it was an essential part of his results as all can see, and the photographer with whom I most associate him is his namesake Frederick Evans (1853-1945), a bookseller who became a photographer of infinite patience and accomplishment, but who gave it up completely when

Of his picture of David Hockney, originally shot for *Vogue*, Evans subsequently wrote: 'My first published picture in 1963, long before anyone had ever heard of David Hockney. I think I went to see him on three different occasions and shot four rolls of film with my Rolleicord and a Pentax that I had recently acquired. Then as now, I did not have any pre-conceived ideas about what I wanted. I just looked through the lens until something interesting happened and clicked the shutter.'

the platinum paper essential to his exquisite tonal gradations became unobtainable.

It is surely from growing to appreciate people and things that go against one's own natural grain that make one, if this is possible, a little wiser, and though I didn't at first embrace Tony's personality or his eye – much as I recognised their worth and integrity – I was very soon persuaded, and partly by being obliged to acknowledge the presence of a quiet passion in his work.

So I only took a little time to realise that he was a photographer to his marrow rather than an odd sensitive human being who might just as well have been a teacher, a lay-brother or perhaps even a rather specialised organic chemist – though I had little to do with him when I first took over the Picture Desk of the *Sunday Times Magazine* in 1972. He was nearly always commissioned by the Art Director, Michael Rand to execute or develop design concepts rather than do portraits, reportage or even to photograph objects except on the very rare occasions when they seemed to have a special resonance with his sensibility.

The first picture of his that bowled me over was of a silver teaspoon exquisitely loaded with caviar against a black background, and which was magnified by printing over a double-page spread. Because I love food excessively and also really like caviar, I enjoyed imagining the care with which the spoon had been polished, filled, repolished and filled again until the glistening, expensive and delicious little dark grey eggs looked absolutely right. And I think that Tony, much less of a Puritan than he looked, must have enjoyed them for what they were as well as their look. There are hints of a liking for simple luxury in his work even if concealed in an animal's fur, a burgeoning garden or a picnic spread, and Caroline, his wife, as well as several friends attest to his temperate enjoyment of life's proper indulgences.

The impulse to make photographs, if they are to be any good, is certainly a very subjective one, and a photographer who works on commission is often chosen for his personal peculiarities as much as for his pictorial/technical skill. So Tony Evans's body of work is just as intensely his own as that of one working to please himself with no thought of material reward, and I think there is no doubt that he

needed the problems presented by commercial briefs to become the artist he very certainly was. Being commissioned after all has made many kinds of artists more productive.

It may seem surprising that three of his greatest triumphs in advertising were for cigarette promotion, but after all, the whole outrageous concept of Benson and Hedges Gold was a brilliant one. Everyone no doubt has their favourite image, but Tony's unearthing of the Roman mosaic is to me the most stunning. Perhaps it says that he could have become an archaeologist – or even a master blacksmith it might seem with the nearly as ingenious forging of the B&H logo. The fountain pen (three feet long and very painstakingly crafted) was probably as effective as any – exploiting, it seems, the curious nostalgia that pens can provoke in a largely ball-point age. But whoever dreamed up these ingenious and bizarre ideas – in these cases largely the highly imaginative John Merriman – without Tony Evans they would surely never have been so memorable.

With human beings Evans's results are often satisfying but rather strange. The extraordinarily rapid changes that human expressions and demeanours go through did not, it seems to me, quite suit him in terms of control. So while he always took his customary pains (so well described in the other tributes here) with portraiture it often seems that he has just stopped his subjects in their tracks, arranged them very simply, and shot. With the Goons this worked very well. The *Radio Times* cover is a completely singular and strangely rewarding view of them, and somehow his seeming to make the imperturbable Stanley Holloway not quite certain of himself gives us an entirely new but convincing view of the great Englishman, and this may have truly expressed the subject's feelings about his late-in-life and not too successful series that the picture was taken to publicise. But I think that the great portrait of the gorilla in Gerald Durrell's zoo must have been infinitely more congenial for Tony, as were probably the marvellous RSPCA postage stamp animals in which he gave a very gently sardonic twist to the notion of cuteness without spoiling anyone's simple pleasure.

But Tony Evans's greatest masterpiece is surely *The English Sunrise* earning him, as it turned out, no money but something more,

the satisfaction of having created one of the most thoroughly enjoyed picture book presents ever printed. After all the concurrent coffee-table indulgence in sophisticated art deco and art nouveau, it shines like a modest but surely priceless gem, showing us how important, even indispensable, the sunburst or sunrise motif has been on the humbler levels of British life. No-one would be quick to admit that a crude fusebox had been enhanced a little by some clumsy cast-iron delineation of radiance, but somehow, and in the absence of more sophisticated or expensive embellishment or simplification, it might well have been – and such things may still help to oil the wheels of the daily British round to a surprising extent. Tony Evans conceived the character of the photographs perfectly. Although very carefully framed, the images are as understated or everyday in feeling as the artefacts, trade marks etc themselves are. One may not get much positive uplift by wandering the streets where the English Sunrise rules or once ruled, but Tony Evans's little images simply make one feel better about the dull places which badly needed this simple relief, and which their inhabitants might – perhaps to their surprise – sorely miss. The book also stifles any patronising feelings as it offers us its curiously moving experience.

Both *English Cottages* and *The Flowering of Britain* are rare masterpieces of self-effacement as well as illustration. They are neither post-cards, beautiful as they can be, or pictures to coo over. Rather they are serious and nearly always successful attempts to do justice to their subjects, with the variety of focus and viewpoints surely not at all intended to 'dazzle' as the jacket blurb for one of them suggests that they do. Tony also deliberately and patiently went for all kinds of weather and its variety of lighting. With the cottages you are told exactly what they are like – they don't nourish fantasies – and with the flowers you are made to feel their solitude in nature as well as their happily available beauty, whether to the bees or the human race.

I was very gratified to have had a hand in publicising his last achieved and somehow appropriate project of the opening Iris. He was very pleased to see it in the *Independent Magazine* (which was at the time interested in the visual arts) and it was printed pretty well. I liked his very unprecocious idea of turning this series and others –

the next one would have been a rose – into flick books but unfortunately this was not considered commercially viable and he then had little time left to press for it.

Caroline Evans (now Edwards) is the determined guardian of Tony's reputation, and this book and attendant exhibition are, with the encouragement of many friends, largely her own and David Hillman's work. She tells me that her son and daughter with Tony, James and Flora, take after their father and she says that James handles everything with the same entirely natural care as Tony did – 'a piece of paper as if it was made of porcelain'. I feel sure that very special artists such as Tony Evans, producing images seen by millions, may register, however subliminally, their singular value on a mass of people far beyond those who readily recognise it. This would give their work a certain nobility, make them public benefactors of a kind not yet sufficiently recognised.

Tony Evans in the studio at his home in Montgomeryshire, taken by Douglas Maxwell on a visit in 1983.

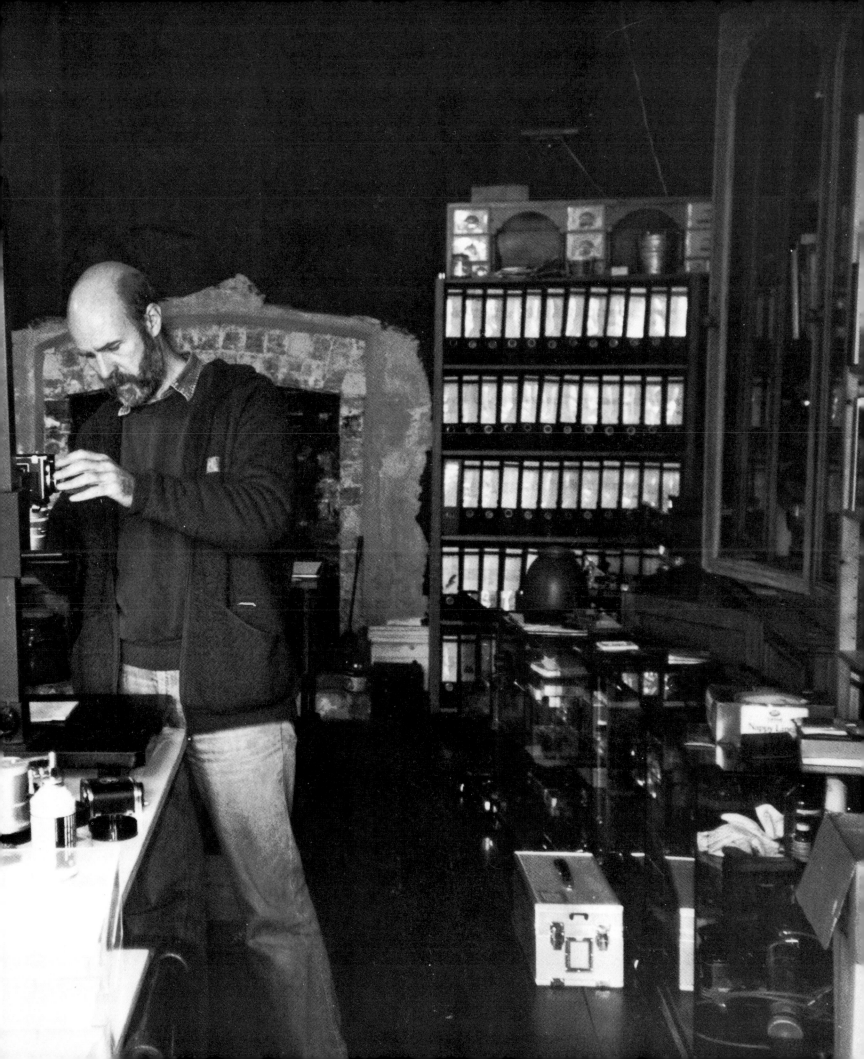

Tony Evans received numerous awards during his career. These include:

1967
D&AD Silver Award Best Newspaper Advertisment.
'The Human Jungle' for Remington.
Agency: Doyle Dane Bernbach. Art Director: Neil Godfrey.

1968
D&AD Silver Award Best Newspaper Advertisment.
'A little Drop of Rain...' for Uniroyal.
Agency: Doyle Dane Bernbach. Art Director: Doug Maxwell.

1968
D&AD Silver Award Best Advertising Campaign.
'The Rain Tyre' for Uniroyal.
Agency: Doyle Dane Bernbach. Art Director: Doug Maxwell.

1969

D&AD Special Mention for Technical Excellence.
'Sheep in Oxford Street' for Debenham's.
Agency: Vernon Stratton. Art Director: Bob Marchant.

1973
D&AD Gold Award Most Outstanding Item of Design.
D&AD Silver Award Most Outstanding Book Design.
D&AD Silver Award Most Outstanding Book Photography.
The English Sunrise.
Authors: Tony Evans and Brian Rice. Art Directors: Tony Evans and Brian Rice. Designer: David Hillman.

1975
The D&AD Silver Award Most Outstanding Specialist Feature.
'The World Cup'. *Radio Times.*
Art Director: David Driver. Designers: David Driver and Derek Ungless.
Illustrators: Peter Brookes and Richard Draper.
Photographers: Allan Ballard, Michael Brennan, Roger Jones, Dimitri Kasterine, Robert McFarlane, Keith McMillan and Tony Evans.

1976
The D&AD Silver Award Most Oustanding Editorial Design.
'Behind the scenes'. *Radio Times.*
Art Director: David Driver and Robert Priest.
Designers: David Driver, Peter Brookes and Nigel Holmes.
Illustrators: Peter Brookes and Nigel Holmes.
Photographer: Tony Evans.

1976
The D&AD Silver Award Most Oustanding Illustration
'It's about as likely as a duff bottle of Hirondelle' for Hedges & Butler.
Agency: J Walter Thompson. Art Director: Tony Muranka.
Illustrators: Wayne Anderson, Barry Craddock, Pauline Ellison, Larry Learmont and Peter le Vasseur. Photographers: Bob Cramp, Tony Evans and John Knill. Copywriter: Ken Mullen.

1980
Campaign Poster Awards Silver Award for Best Photography.
'Fountain Pen' for Benson and Hedges.
Agency: Collett Dickenson Pearce. Art Director: Graham Watson.

1984
D&AD Silver Award Nomination for Complete Book.
Lark Rise to Candleford by Flora Thompson.
Designer: Nick Thirkell.

1984
D&AD Silver Award Most Outstanding Single Poster.
'Red Monarch' for Goldcrest. Designers: John Gorham and Howard Brown.

1984
D&AD Silver Award Best Colour Advertisement, Consumer Magazines.
'Spiders' for the Central Office of Information.
Agency: TBWA. Art Director: Malcom Gaskin.

1988
D&AD Award Nomination Silver for Complete Book.
'*Trees*'.
Art Director: David Pocknell. Designers: David Pocknell and Duncan Moore. Illustrators: and painters: Michael Rothenstein, S R Badmin, M Cooper, Ivan Powell, Brian Cook, Ben Levene, Graham Hogarth, Margaret Green, John Aldridge, Tom Purvis, John Nash, George Hardy, Rowland Hilder, Eric Ravillious, Peter Coker, Peter Blake and Ruskin Spear. Photographer: Tony Evans.

ACKNOWLEDGEMENTS

Tony Evans produced his own acknowledgement
list before he died in 1992. It is reproduced here.

'I like to work, with people I like, whose work I like.

The list of clients and friends I have worked for over
the years includes:

Alan Aldridge	Robert Maude
Paul Briginshaw	Doug Maxwell
Howard Brown	John Merriman
Ron Brown	Duncan Moore
Robert Brownjohn	Colin Morris
Jennie Burns	Rob Morris
Stafford Cliff	Tony Muranka
Clive Crook	John McConnell
Dick Davis	Bruce Nivison
Mike Dempsey	Jim Northover
David Driver	Graeme Norways
Robert Entwistle	Alan Parker
Rodney Fitch	David Pearce
Willi Fleckhaus	David Pelham
Alan Fletcher	Dominique Pennor's
Colin Forbes	Tor Petterson
Derek Forsyth	David Pocknell
Malcolm Gaskin	Robert Priest
Ray Gautier	Robert Purdie
John Gibbs	David Puttnam
Bruce Gill	Michael Rand
Neil Godfrey	Angela Reeves
John Gorham	Barry Robinson
Kenneth Grange	John Rushworth
Jonathan Hall	John Spencer
John Hegarty	Rod Stringett
David Hillman	Amanda Tatham
David Holmes	John Tennant
Nigel Holmes	Nicholas Thirkell
John Horton	Pat Tofts
Mervyn Kurlansky	Tony Vines
Mike Lackersteen	Martyn Walsh
David Larkin	Graham Watson
Herb Lubalin	Brian Webb
Cherriwyn Magill	Nancy Williams
Bob Marchant	Michael Wolff'

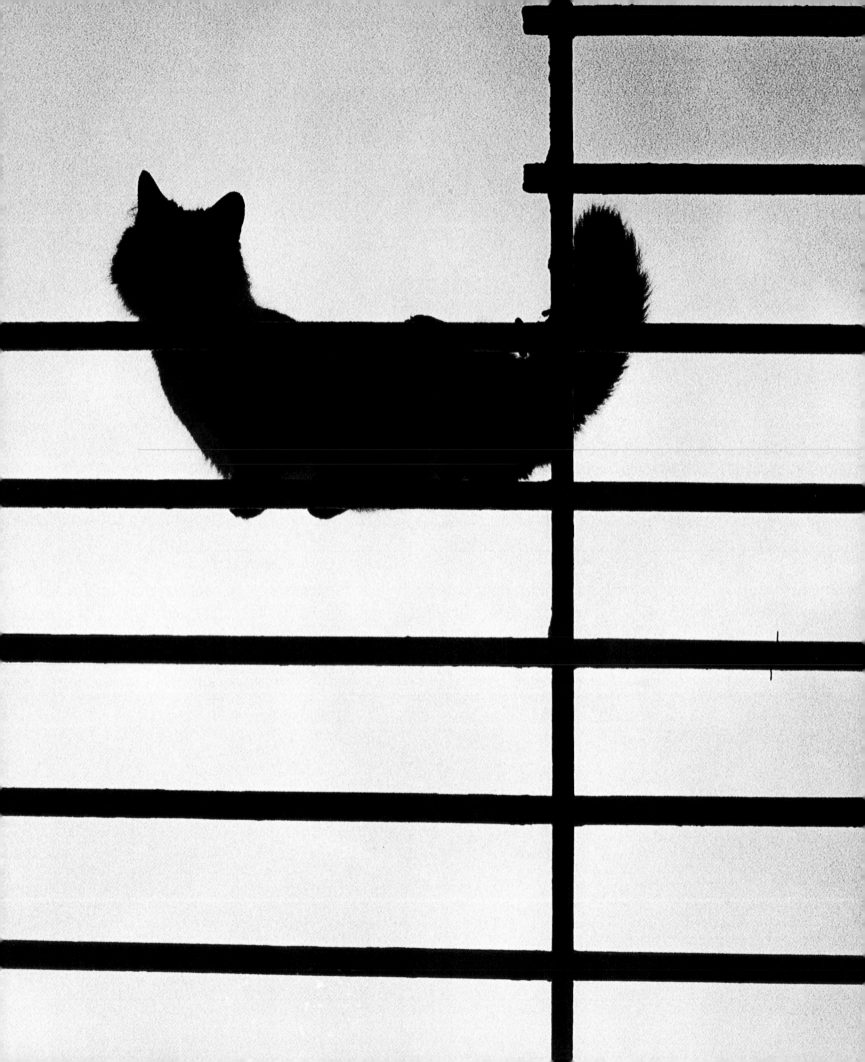

1963-1971

Soon after Tony Evans had moved to London in the early 1960s, he took a job with a market research company and there met the young artist Brian Rice. They established a friendship which was responsible for first arousing Evans's interest in the visual arts. It was no passing fad. Having already tried agriculture and electronics amongst other things, he went through his career options and decided on photography. In 1963 he had his first success when Vogue *published a photograph he had taken of the young David Hockney.*

He gradually made his mark with editorial photography for such magazines as Tatler, *the* Sunday Telegraph Magazine *as well as* Vogue. *He won the Ilford Award in 1965 and an article about him appeared in the* British Journal of Photography *the same year. By the end of this period his advertising photography also began to attract wide attention, particularly his work with the Douglas Maxwell/David Abbott 'dream team' at Doyle Dane Bernbach and Bob Marchant at Vernons. In 1968 he met Caroline through Don Silverstein. They were married in 1969.*

A cat wandered into painter Brian Rice's studio during a shoot for an exhibition of the artist's work. The picture was published in the *British Journal of Photography* in 1965.
1964. Asahi Pentax 35mm
Kodak Tri-X Pan

Cover for the Henley issue
of *Tatler* in July 1965, for which
Evans was paid 30 guineas
(£31.50). The model was
Jenny Smith.
1965. Rolleicord
Kodak EHB

Cover for the Corgi paperback
Looking After Your Cat. The
photograph was used again in
1970 for a calendar designed
by John McConnell promoting
the printers Stephen Austen.
The cat was called Marcus.
1968. Hasselblad
Kodak Ektachrome

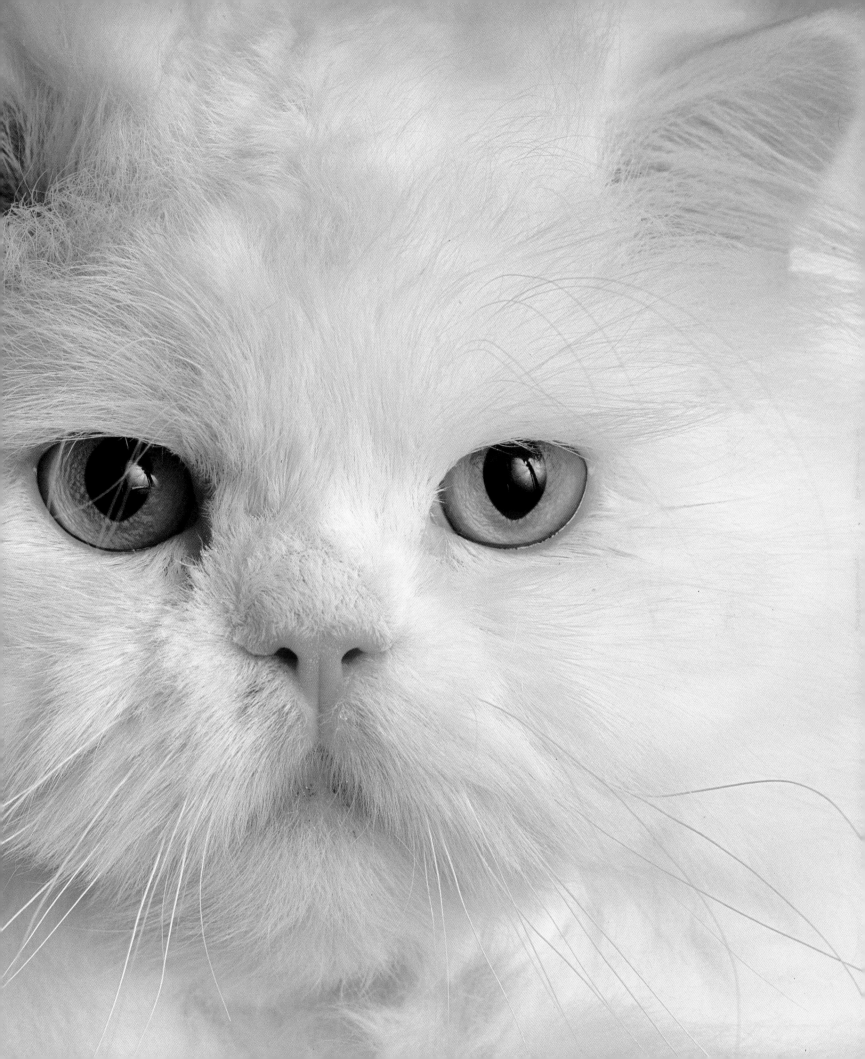

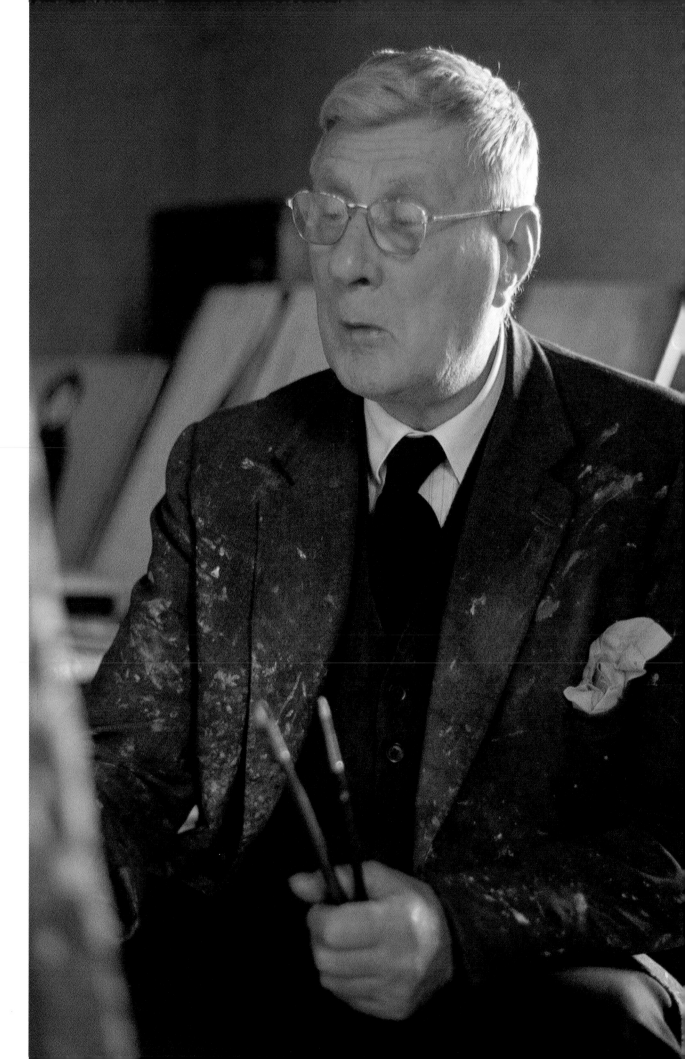

Portrait of L S Lowry at his home in Manchester, taken for Edwin Mullins at the *Sunday Telegraph* and later used for a Tate Gallery poster.
1964. Asahi Pentax 35mm Kodak Tri-X Pan

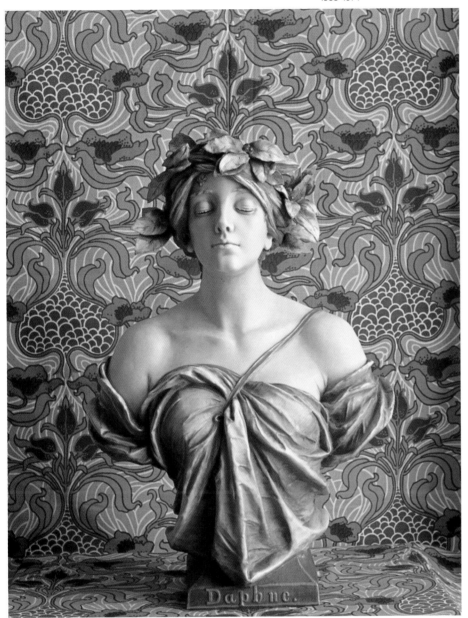

From a *Sunday Times Magazine* article on art nouveau, a life size porcelain bust of Daphne based on a painting by Sir Herbert von Herkomer. 1965. Asahi Pentax Kodak Ektachrome

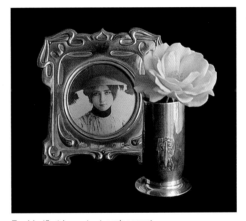

For his 'first important assignment for the *Sunday Times Magazine*' Evans visited a collector of *objets* art nouveau. Over lunch in his garden, the man produced a spectacular blue rose – to go with the silver vase chosen for the photograph. 'Blue flowers have a sneaky side to them,' wrote Evans afterwards, 'in photographs they can appear pink, and this one did just that; changing literally overnight, from a true-blue aristocrat to a pink-faced commoner. In spite of this Jekyll-and-Hyde performance by the rose, the photograph was chosen for the cover and I was well pleased.' 1965. Asahi Pentax Kodak EHB

Photographs for Edwin Mullins at the *Sunday Telegraph* of the young bloods of the art world: Dick Smith (*far right*), Howard Hodgkin (*right*) and Allen Jones (*above*), Together with the photograph of David Hockney on page 6, these subsequently appeared in the book *London: The New Art Scene*, published by the Walker Art Center.
1965. Asahi Pentax
Film unrecorded

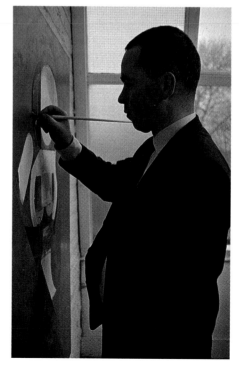

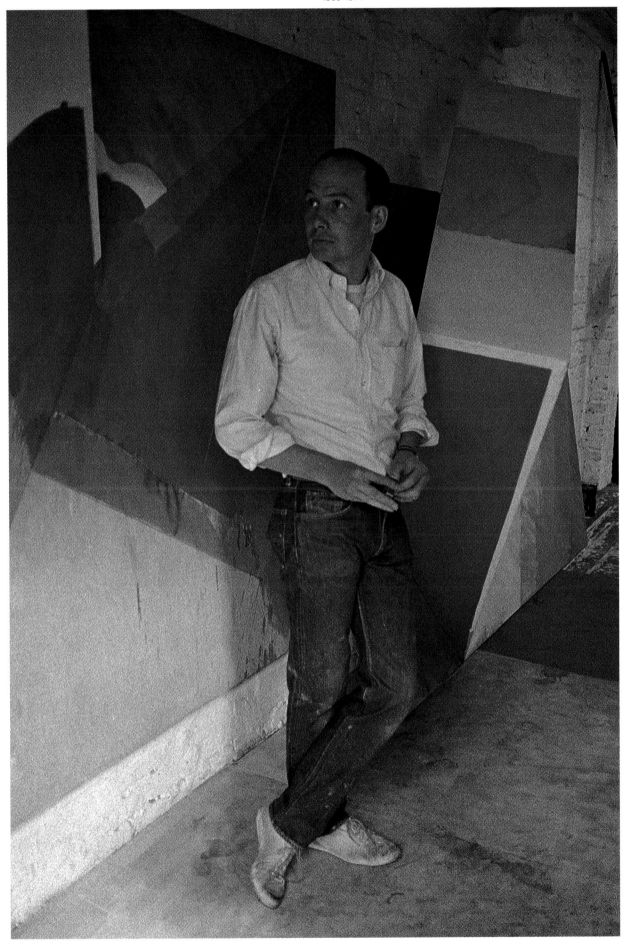

Peter Blake in his garden in
Chiswick, west London, for a
feature in *Tatler*. Evans was
later invited to take the pictures
when Blake married Jan Howarth
in July 1963. Something entirely
out of character happened
that day – perhaps the most
meticulous photographer of all
forgot to take the lens cap off.
1963. Camera and film unrecorded

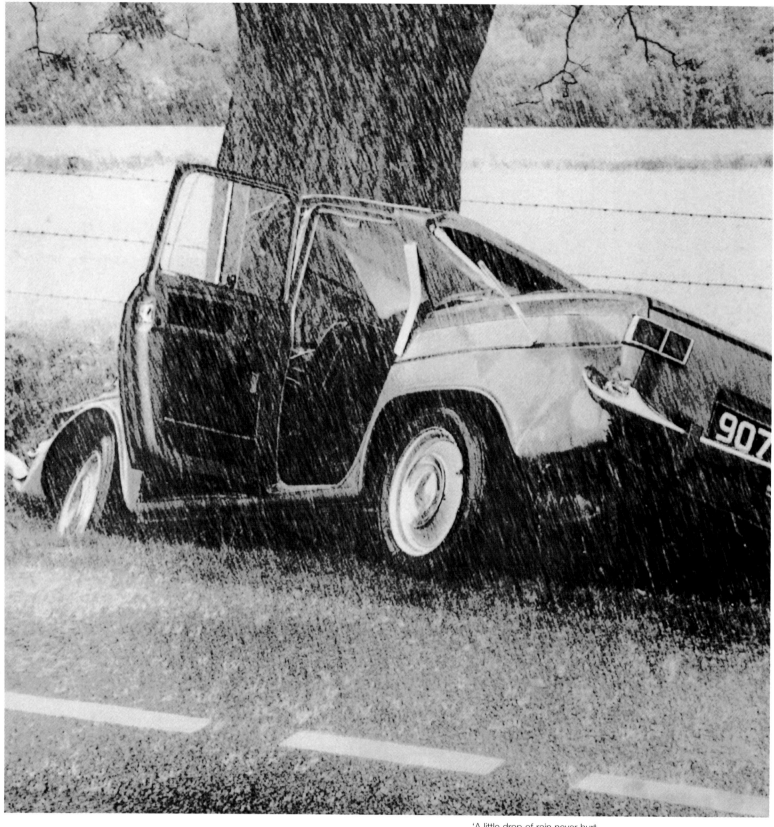

'A little drop of rain never hurt
anybody', the Rain Tyre ad that
won the D&AD Silver Award for
Best Newspaper Advertisement in
1968. Art director, Doug Maxwell;
copywriter David Abbott
1967. Hasselblad
Kodak Tri-X Pan

Douglas Maxwell was a young art director at Doyle Dane Bernbach – perhaps London's hottest agency in the 1960s – when he first met Tony Evans. In 1968, Herb Lubalin, New York art director and designer, described Maxwell and Evans as 'the most exciting creative team working in Europe'.

'He'd never done any ad photography before.'

Douglas Maxwell

When I first met Tony it was at a *Sunday Times* party. I was introduced by my wife, Susan, who was a designer on the colour supplement. She had urged me (on the strength I might add of a few still-lifes of his), to use him. She had met Tony when working on a layout featuring the work of two young interior/furniture designers. Tony was downright diffident. He'd never done any ad photography before (I later found out that he'd hardly done *any* photography before!) and anyway, it was all too 'commercial'. Thank goodness I wasn't put off!

I think the first ad he finally succumbed to doing for me was a trade ad for the Polaroid Camera. It was a still-life of a camera. The headline was: 'The 30 second Carrot' (copywriter, John Salmon); it took him a darn sight longer – several days – to take the picture! It was a beautiful picture and won Best Trade Ad Of The Year Award.

These days, doing what we did in manipulating and retouching, can be done at the touch of a computer button. Then, it was a very difficult, painstaking and meticulous process. Tony revelled in it all. And so, I confess, did I. But we couldn't have achieved what were breathtaking results without the patient genius of Phil Meyer. Phil brought new techniques from America. To him,

The first photograph Evans took for an advertisement: 'The Human Jungle' for Remington razors, which won a D&AD Silver Award in 1967. The art director was Neil Godfrey and Doyle Dane Bernbach. Evans was persuaded somewhat reluctantly at first to work in advertising by Douglas Maxwell, who was also an art director at the agency.
1967. Hasselblad
Kodak PX

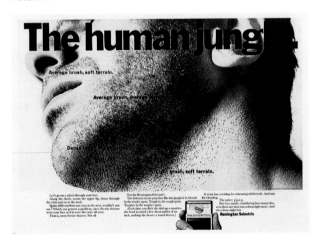

27

nothing was impossible – well, almost nothing. This
suited Tony down to the ground.

I was a very demanding and very young Art Director
at Doyle Dane Bernabch. My 'visuals' usually have left
a lot to be desired. On more than one occasion Tony
jokingly looked at them upside down – but I knew what
I wanted, and discussed them at considerable length
with Tony. To him taking the photographs (there were
often several to make one image) was the easy bit.
'Collaging' them together and finally retouching was the
part of the process that Tony really enjoyed. Often when
Phil and I were ready to call it a day, Tony's quiet, insistent
voice, 'Doogie couldn't we just…' or, 'Phil, don't think this
bit here quite works…' was there, gently urging us on.

The two campaigns that helped make Tony's name
(and indeed mine) were 'Big Feet' and 'Rain Tyre' – both
for Uniroyal Tyres, a major client of DDB New York and
in London. The former involved ('impossible' said John
Withers, the copywriter) creating a photographic 'cartoon'
car with enormous tyres. Tony and I talked for hours
about how to do it. Eventually he photographed a Lotus
– jacked up at the front – with a wide angle lens. The
print of the car was then cut in half; this half was then
re-photographed; the neg was flipped, double printed,
and butted up with the original half. Phil Meyer then got
to work…and the end result was a photographic cartoon
– just what the art director had ordered.

This though was easy stuff compared with the Rain Tyre campaign. The most famous of the ads in the campaign was: 'A little drop of rain never hurt anybody!' (copywriter, David Abbott). The picture: a car that had skidded off the road and smashed into a tree. The car couldn't be too mangled; the driver, the client insisted, had to have escaped with a few bruises. It had to look believable too; as if we'd just 'stumbled' on it.

Tony spent days finding just the right stretch of road – with just the right bend and, or course, a tree in exactly the right position. Then there was the car. It had to be the right kind of car, with the right kind of damage too. Tony found it, and not quite satisfied, added a few dents of his own. Got it towed to the location, and then called out the fire brigade to provide the rain! The sheer logistics would have daunted most people, but not Tony. He actually enjoyed it. The result was a brilliant, almost 'reportage' picture. The ad itself went on to win every award in sight.

I continued to work with Tony long after I left DDB and started my own company. By then Tony was famous, and became one of the most sought after photographers in the country. His work continued to amaze people. Towards the end of his life, when we were reminiscing, he often said that the DDB years were the most exciting and rewarding time of his life. And, thanks to you Tony, they were for me too!

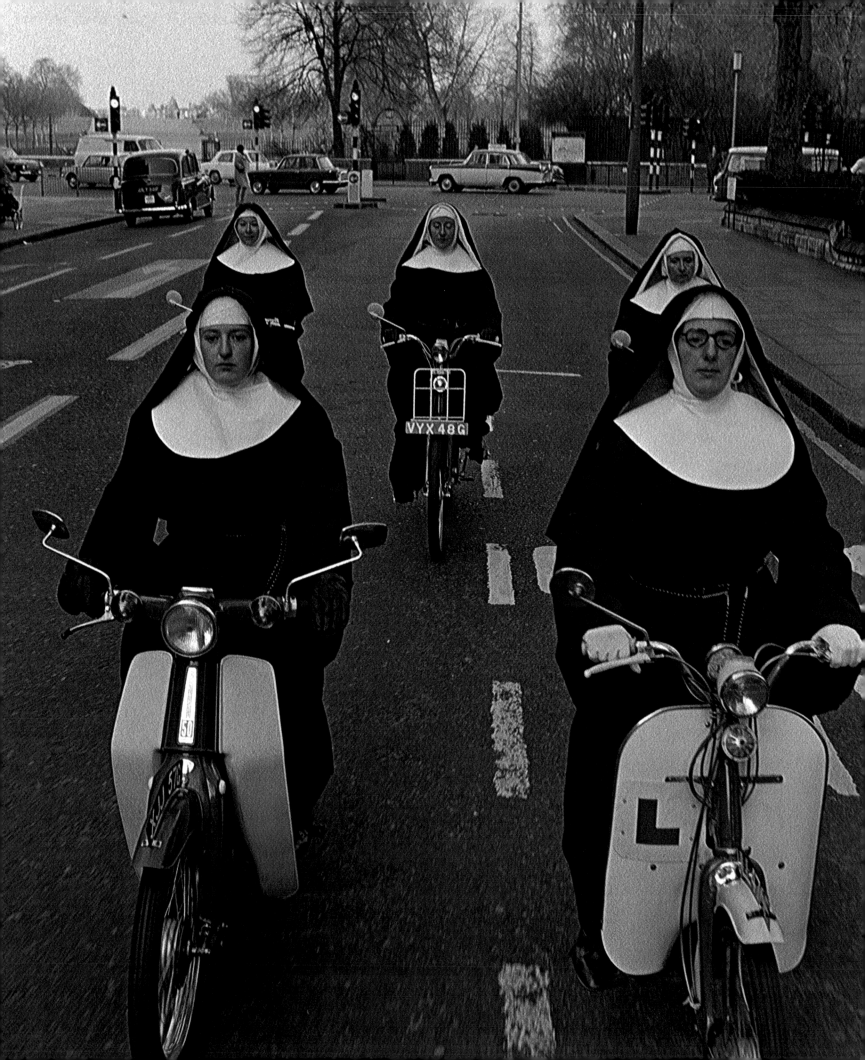

A series of press advertisements
for Honda, when they were
known only for their bikes. The
nuns and the housewives were
taken in Gloucester Road, west
London, and the factory shot
had more people retouched in
later to fill up the yard, which
was cheaper than hiring extras.
The agency was KMP and the
art director was Michael Kidd.
1968. Hasselblad and
Nikon 35mm
Kodak Tri-X Pan

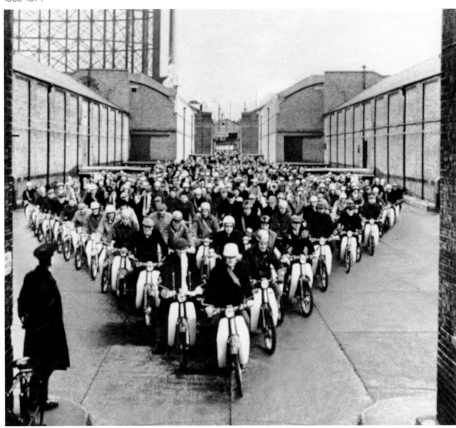

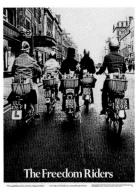

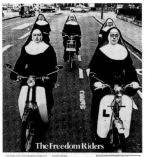

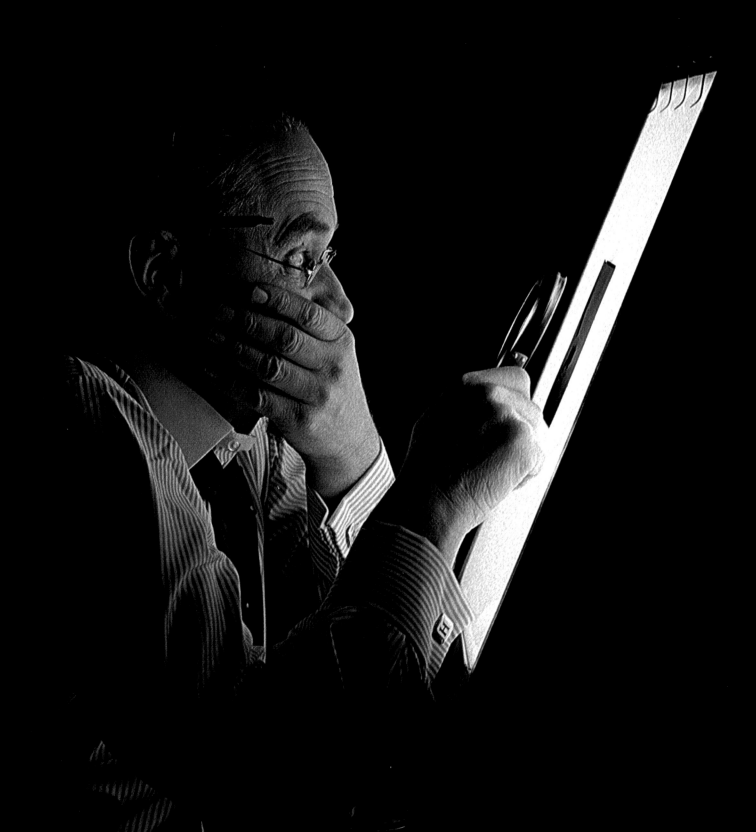

For a trade advertisement for
Transcolour, photographic print
specialists, Evans worked with
art director Doug Maxwell.
1967. Asahi Pentax
Kodak Tri-X Pan

Stanley Holloway was
photographed for a London
Weekend Television advertisement
and poster. The art director was
Doug Maxwell and the agency
Doyle Dane Bernbach.
1968. Hasselblad
Ilford FP3

Following pages.
Ray Charles on tour in London,
taken for the *Sunday Telegraph*.
1964. Asahi Pentax
Kodak Ektachrome

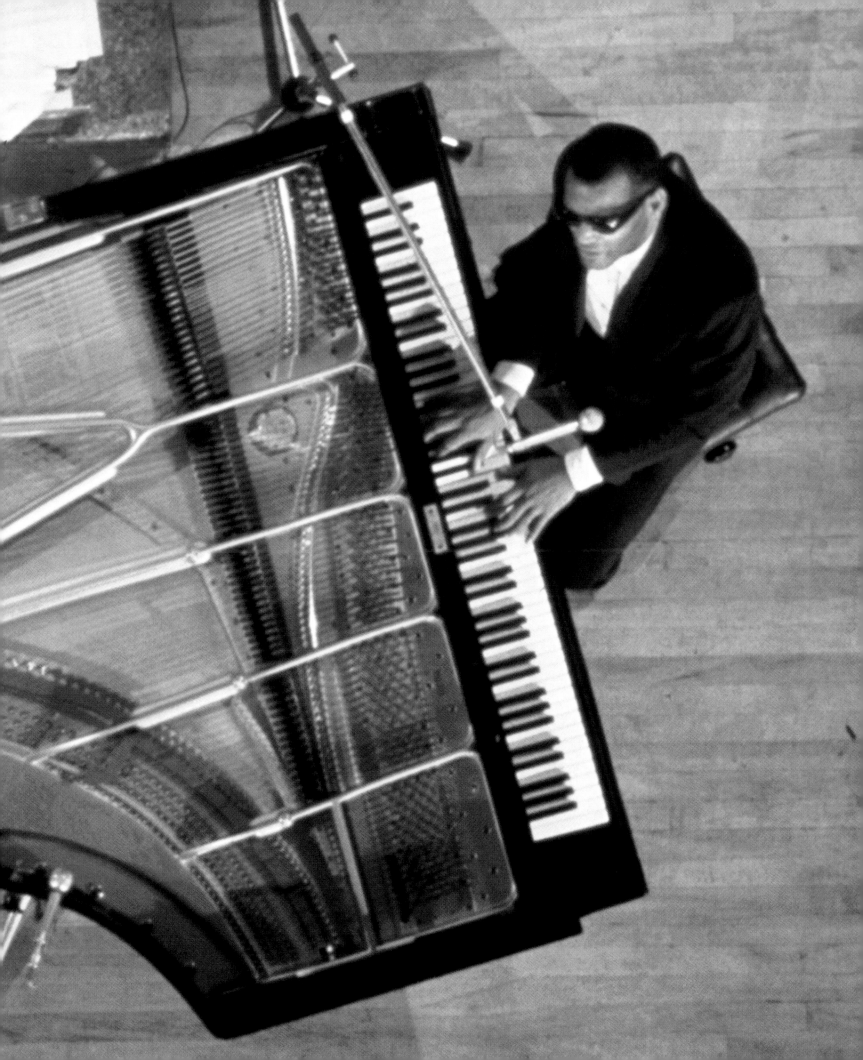

Big Feet:
how Uniroyal keep fast cars on the road.

They don't look like ordinary tyres do they?

And they're not.

They're Big Feet. (Officially known as Uniroyal's new Rallye 220s.)

With Big Feet under you, you can do things you couldn't do on ordinary tyres:

Like 100 miles at 115 mph. Without stopping.

Or 15,000 miles at 85 mph. Without failure.

You can hot-foot it around bends you'd only shuffle into on other tyres.

Even in the rain.

Why?

It's very simple: Big Feet have big footprints. (The biggest in Europe.)

So there's always a lot of tyre in contact with a lot of road.

And that's just as sensible as it sounds.

The fact is, you're safer on Big Feet at 118 mph, than you are on some other tyres at 90 mph.

(This isn't just a figure of speech; we proved it in tests.)

All of which should convince you that Big Feet are pretty fast on their feet. But what about noise? And wear? Something has to suffer.

We were waiting for that.

On test runs over pavé, Big Feet were 25% quieter than similar performance tyres. Which should silence any doubts you have about noise.

And as for wear, well, any tyre that can go 15,000 miles at 85 mph (at this speed, tyres wear out twice as fast as at 50 mph) is no slouch in that department either.

Big Feet by Uniroyal.

You'll find them at your local tyre dealers.

Raring to go.

UNIROYAL

Right.
Bob Marchant, art director at Aalders Marchant Weinreich, commissioned Evans to work on this experimental advertisement for the strange Italian drink Fernet Branca, which was marketed in the UK at the time as a hangover cure.
1970. Asahi Pentax
Ilford FP4

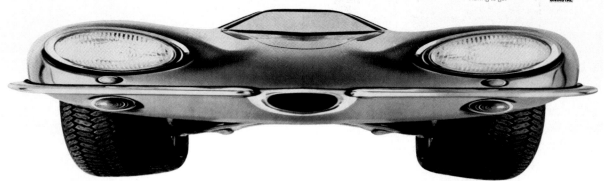

The 'Big Feet' Uniroyal campaign was created by Doug Maxwell and David Abbott at the agency Doyle Dane Bernbach. How did Evans get the car to look like that? In the studio, the car – a Lotus Elan – was jacked up and the front wheel and steering connections were removed to allow maximum amount of tyre to show. The front wheels had ropes attached to them so that their angle could be quickly altered by assistants standing out of shot. In the chosen frame, the left half of the car was distorted in the enlarger and the print copied. The copy negative was flipped and used to make the right half of the car. The two parts were joined together and the hairline between them removed by retouching.
1967. Asahi Pentax
Kodak FX

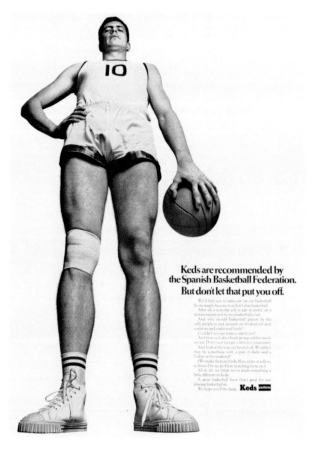

Keds are recommended by the Spanish Basketball Federation. But don't let that put you off.

The 7ft Polish athlete John Murcynowski was hired for this Keds sports shoes advertisement and the ball glued to his hand for the shot. The art director was Neil Godfrey and the agency was Doyle Dane Bernbach.
1967. Hasselblad
Kodak PX

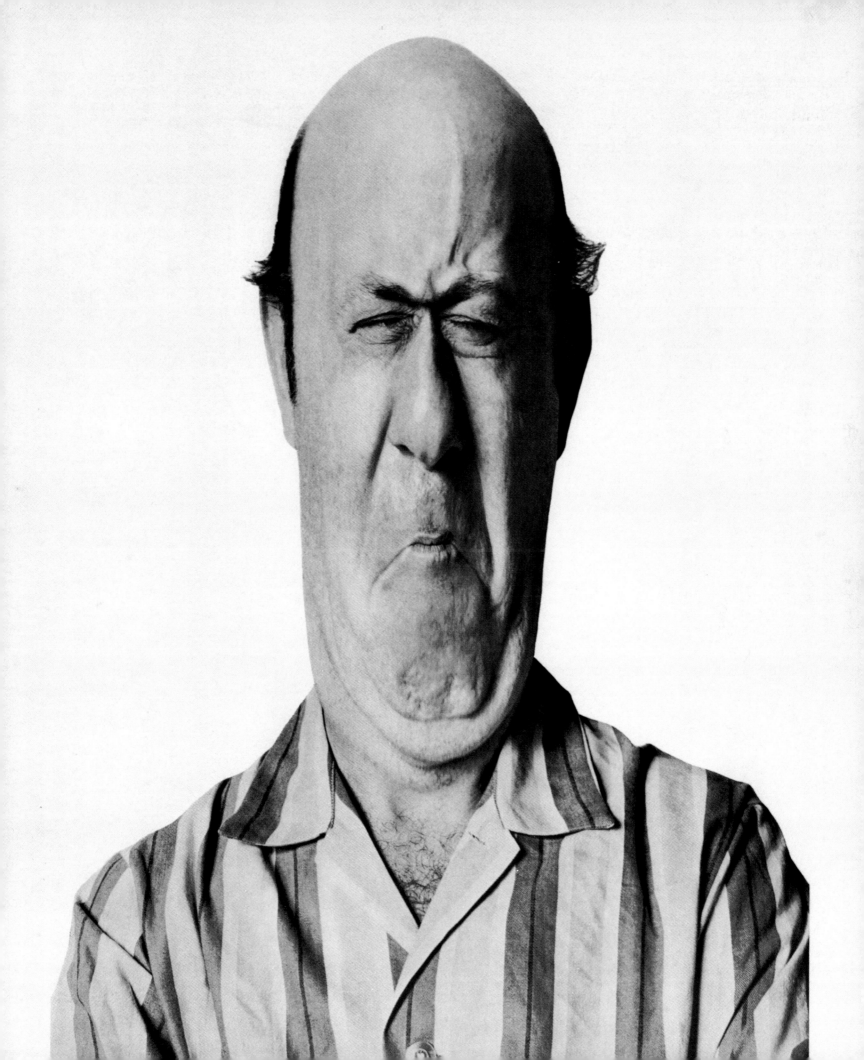

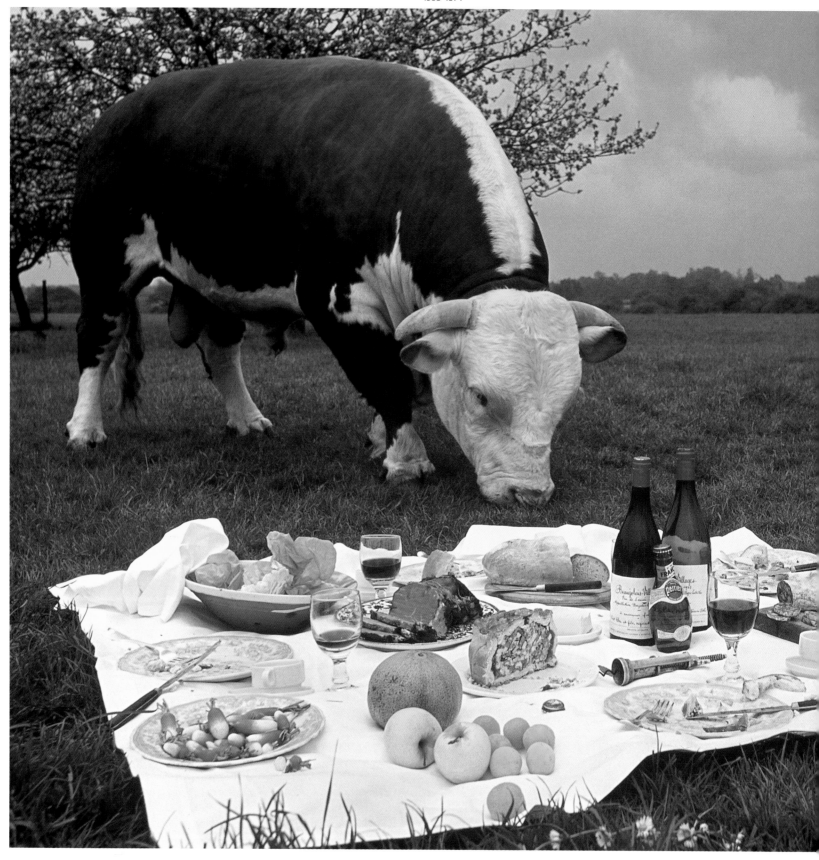

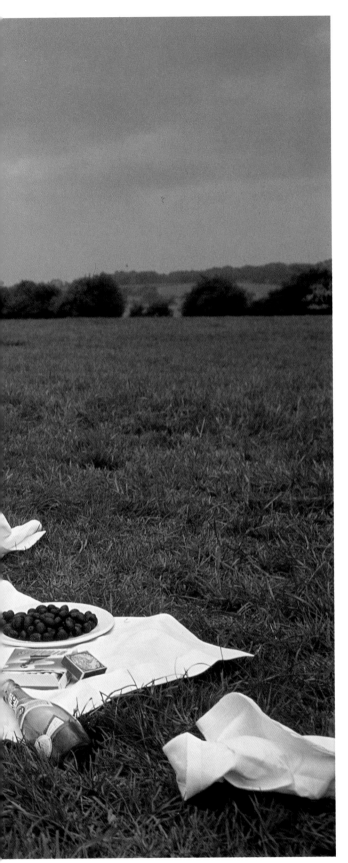

This picture solved a problem that designer John McConnell had illustrating an article on 'winter weekends in the country' in the winter 1968/69 issue of *New Doctor*. Evans originally took the photograph for himself in Denmark during the Christmas holidays in 1965.
1965. Asahi Pentax
Kodak Ektachrome

For his first assignment for *Nova* magazine, Evans was commissioned by its new art director David Hillman to take the pictures for a Caroline Conran feature on picnics. There are no double shots or retouching here – the picture is real, set up with a docile enough champion Hereford bull.
1969. Hasselblad
Kodak Ektachrome

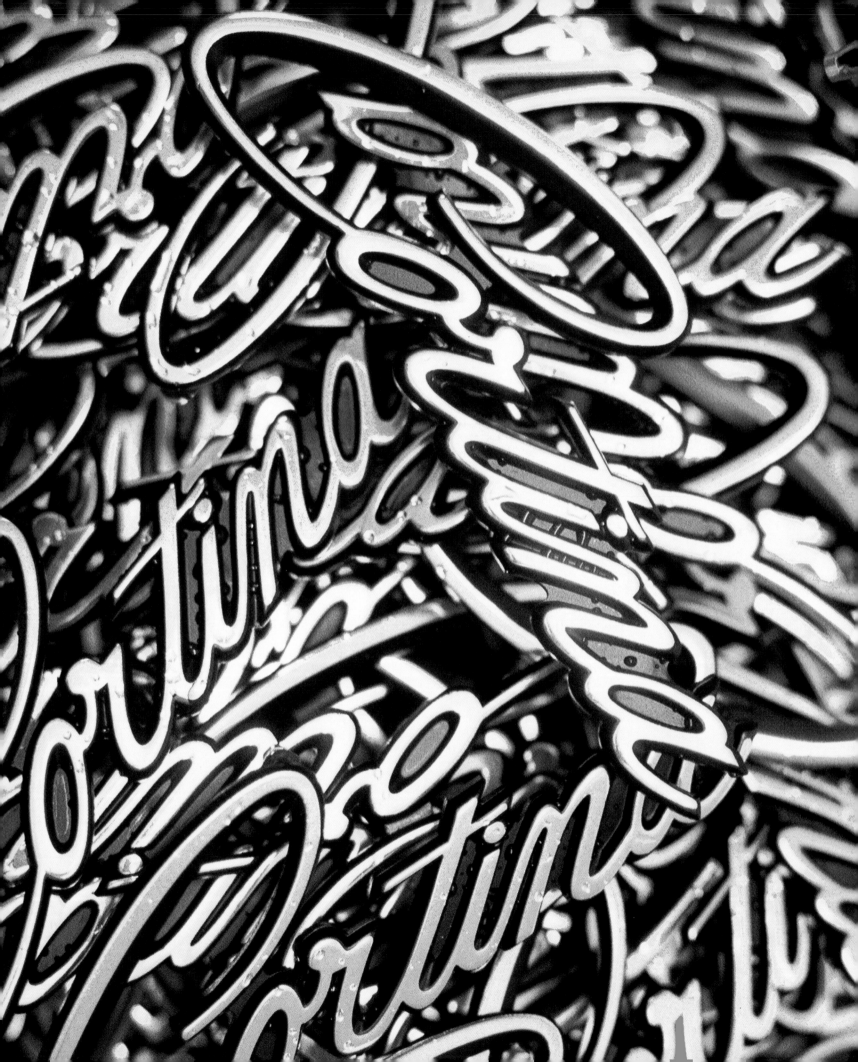

A pile of Ford Cortina
badges in a car trim catalogue
called *Practical Glitter* for
Baco Aluminium, designed
by John McConnell.
1968. Asahi Pentax
Kodak Ektachrome

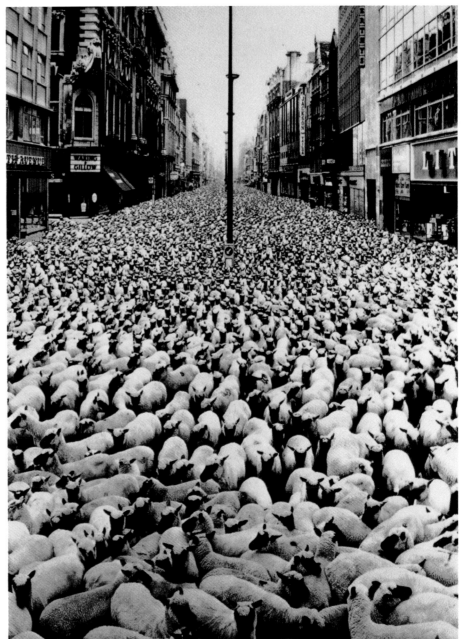

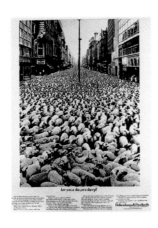

Perhaps Evans's best-known advertisement, in which he contrived to fill Oxford Street with sheep, has become a classic. Created long before the days of computer manipulation, the picture really had people rubbing their eyes. He later wrote about it: 'After the advertisement was published, someone from the BBC telephoned to ask if I had any cine film of the occasion. I suppose in a way it was a compliment that they thought I had actually moved all those sheep into the centre of London. What I did was photograph Oxford Street when it was empty, very early on a Sunday morning. Then I took the relevant measurements, the width, positions of bollards and lamp posts, etc etc. The biggest flock of sheep I could find within reasonable distance numbered about 1,000, which was not nearly enough. So I marked out the width of Oxford Street in a field with electric fences, and used straw bales to make the positions of the bollards and lamp posts. Then I had the sheep driven slowly down the "street" towards me and I kept photographing all the time. The result, when the two pictures were carefully stripped together, was Oxford Street full of sheep.' The agency was Aalders Marchant Weinreich and the art director Bob Marchant.
1969. Hasselblad
Kodak Tri-X Pan

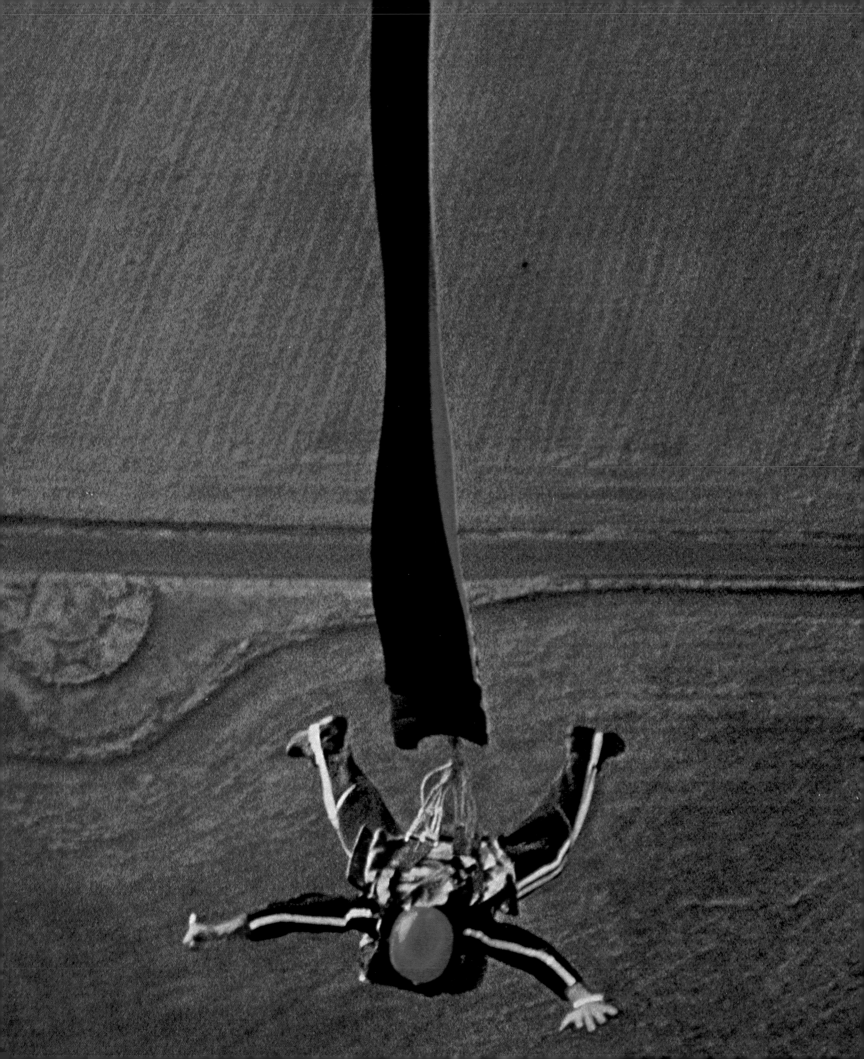

Edwin Mullins has written more than 20 books on painting and sculpture and has been a regular broadcaster for the BBC and ITV on the visual arts. He was art correspondent for the *Sunday Telegraph* and the *Daily Telegraph* in the 1960s.

'He came over like an artist, not an artisan.'

Edwin Mullins

I met Tony in the mid-Sixties, very much in the laid-back Sixties way. He presented himself unannounced one winter day in the decrepit grandeur of the old *Telegraph* building in Fleet Street, a prematurely bald young man with an endearing smile and carrying a portfolio of portrait photographs, mostly of artists he happened to know. I was then art correspondent of the *Sunday Telegraph,* and since I had a weekly column he thought the paper might care to use his stuff. He liked photographing artists at work, he said: it was no good trying to do playwrights, novelists or composers because you couldn't see what they were doing, and who the hell wanted to look at just their faces anyway?

This seemed a promising beginning, so we went out for a drink in the pub over the road to talk it over, and agreed to give it a go. I told him whose work I was likely to be reviewing the following week, and how to get hold of the artist. Tony gave a cheerful shrug. He'd make certain to do uprights as well as horizontals, he said, because if space was tight and there was only room for a thin picture, at least the features editor might not squeeze him out altogether. And he laughed. Then he added, as he ordered his round of drinks, 'You work a

Taken from a Tiger Moth at the 1964 British Parachute Championships. The photograph was used in the German magazine *Twen* in 1966 (see also page 55).
1964. Asahi Pentax
Film unrecorded

The onions in an onion-shaped glass was a concept waiting for a commission. Evans hatched the idea with David Hillman at *Nova* magazine who eventually persuaded Caroline Conran to write a piece on pickles. The trick was achieved using a Perspex onion shape with a plugged opening at the back. The onions aren't actually pickling onions but mature spring onions carefully trimmed and peeled. The onion 'glass' was made by Thorpe Modelmakers.
1971. Nikon 55mm
Kodachrome

Evans had this gas ring made especially by engineer Denis Saunders for an article in *Nova* by Caroline Conran called 'Affectionate Suppers for Two'.
1969. Hasselblad
Kodak Ektachrome

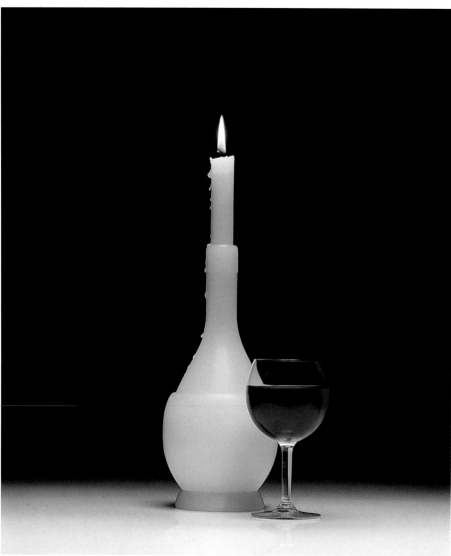

For an article on Chianti in *New Doctor*, Peter Bilson of Thorpe Modelmakers made the bottle out of opaque polythene to look like wax. The art director was John McConnell.
1968. Hasselblad
Kodak Ektachrome

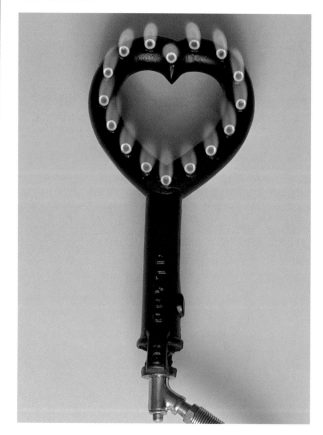

Edwin Mullins has written more than 20 books on painting and sculpture and has been a regular broadcaster for the BBC and ITV on the visual arts. He was art correspondent for the *Sunday Telegraph* and the *Daily Telegraph* in the 1960s.

'He came over like an artist, not an artisan.'

Edwin Mullins

I met Tony in the mid-Sixties, very much in the laid-back Sixties way. He presented himself unannounced one winter day in the decrepit grandeur of the old *Telegraph* building in Fleet Street, a prematurely bald young man with an endearing smile and carrying a portfolio of portrait photographs, mostly of artists he happened to know. I was then art correspondent of the *Sunday Telegraph,* and since I had a weekly column he thought the paper might care to use his stuff. He liked photographing artists at work, he said: it was no good trying to do playwrights, novelists or composers because you couldn't see what they were doing, and who the hell wanted to look at just their faces anyway?

This seemed a promising beginning, so we went out for a drink in the pub over the road to talk it over, and agreed to give it a go. I told him whose work I was likely to be reviewing the following week, and how to get hold of the artist. Tony gave a cheerful shrug. He'd make certain to do uprights as well as horizontals, he said, because if space was tight and there was only room for a thin picture, at least the features editor might not squeeze him out altogether. And he laughed. Then he added, as he ordered his round of drinks, 'You work a

Taken from a Tiger Moth at the 1964 British Parachute Championships. The photograph was used in the German magazine *Twen* in 1966 (see also page 55).
1964. Asahi Pentax
Film unrecorded

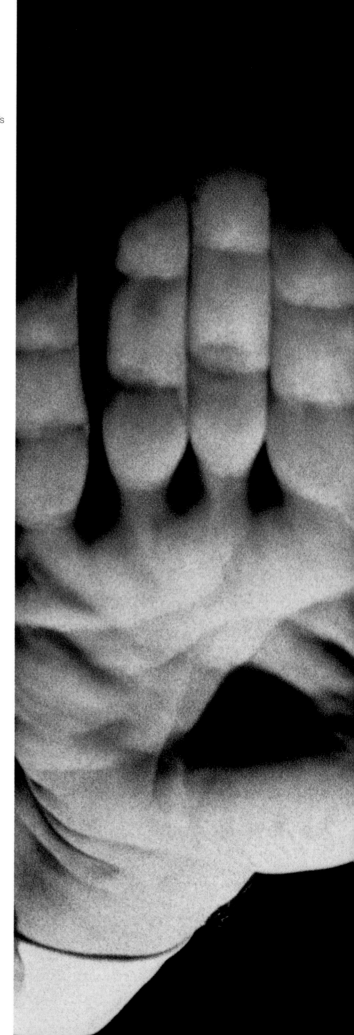

1963-1971
Portrait of Alfred Hitchcock, for the *Sunday Telegraph*. The photograph was lit by a single television spotlight pointing straight up at the roof in Granada's studios during the making of a documentary called 'Cinema'. 1964. Asahi Pentax Kodak Tri-X Pan

lot for the *Daily Telegraph Magazine* too, don't you? Any chance there? I love working on features.'

There are people you like and trust immediately, and I liked and trusted Tony. He was quite different from other photographers and photo-journalists I worked with. On the surface he was deceptively casual, to the point of not always seeming to care. And he was amusingly scathing about colleagues who needed a team of sherpas to carry their spare Hasselblads and torpedo-like lenses wherever they went, preferring to give the impression that he himself did it all with a Box Brownie – or, more truthfully, that a photographer's gift was in the eye, not the equipment. He came over like an artist, not an artisan. And his work, even mug-shots of faces which could have looked like passport photos, invariably lived up to it. He made people interesting who often weren't, somehow – in a way I've never quite understood with good photographers – projecting his own intelligence on to his subject.

I did only very few feature stories with him, which I regret because Tony was a delightful travelling companion who knew exactly when work should stop and other things along the way were far too interesting to miss. He liked to think as much as to work, and I always felt that his unusual kind of talent must soon blossom in a far more original way than mere humdrum reportage. And of course it did.

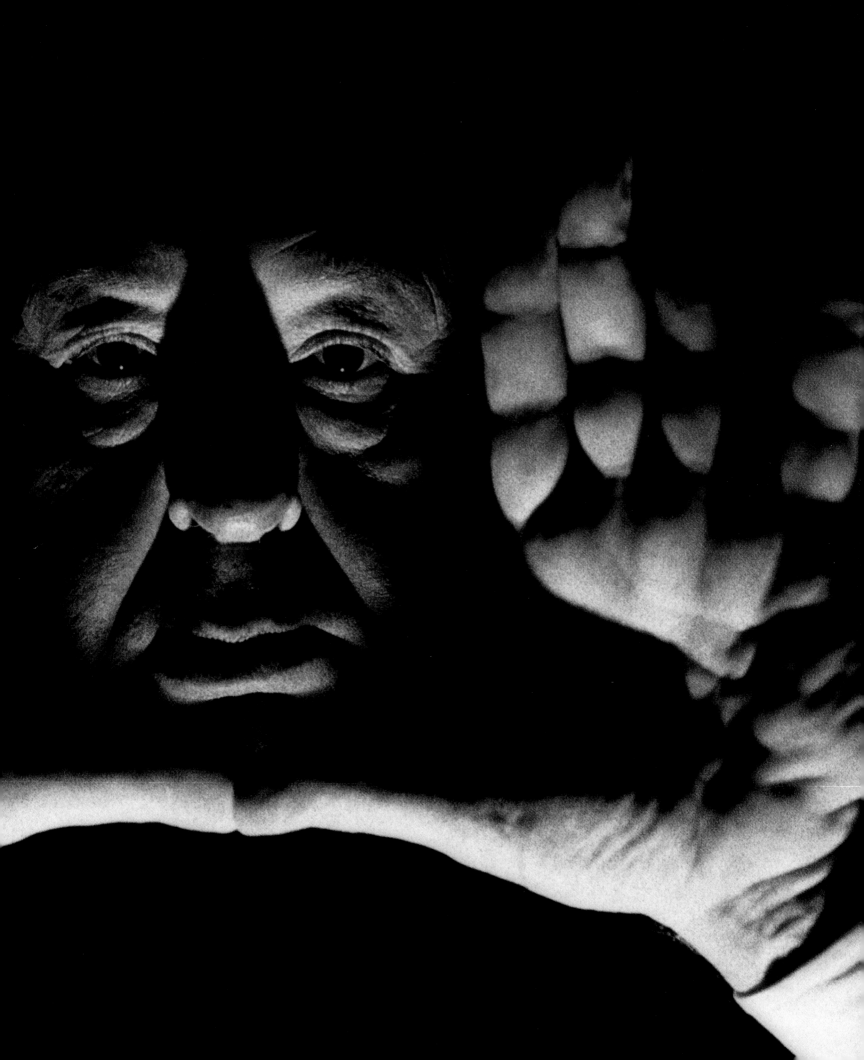

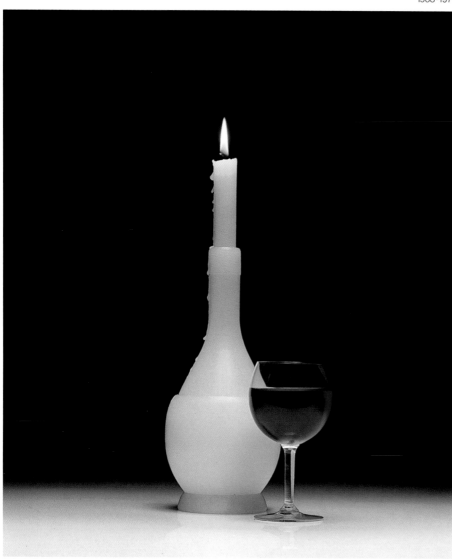

For an article on Chianti in *New Doctor*, Peter Bilson of Thorpe Modelmakers made the bottle out of opaque polythene to look like wax. The art director was John McConnell.
1968. Hasselblad
Kodak Ektachrome

The onions in an onion-shaped glass was a concept waiting for a commission. Evans hatched the idea with David Hillman at *Nova* magazine who eventually persuaded Caroline Conran to write a piece on pickles. The trick was achieved using a Perspex onion shape with a plugged opening at the back. The onions aren't actually pickling onions but mature spring onions carefully trimmed and peeled. The onion 'glass' was made by Thorpe Modelmakers.
1971. Nikon 55mm
Kodachrome

Evans had this gas ring made especially by engineer Denis Saunders for an article in *Nova* by Caroline Conran called 'Affectionate Suppers for Two'.
1969. Hasselblad
Kodak Ektachrome

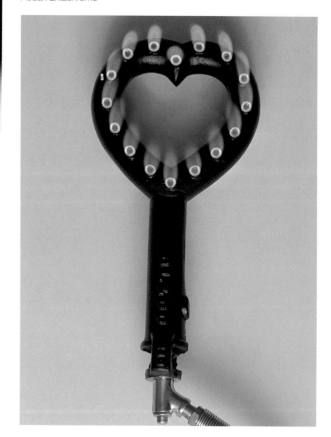

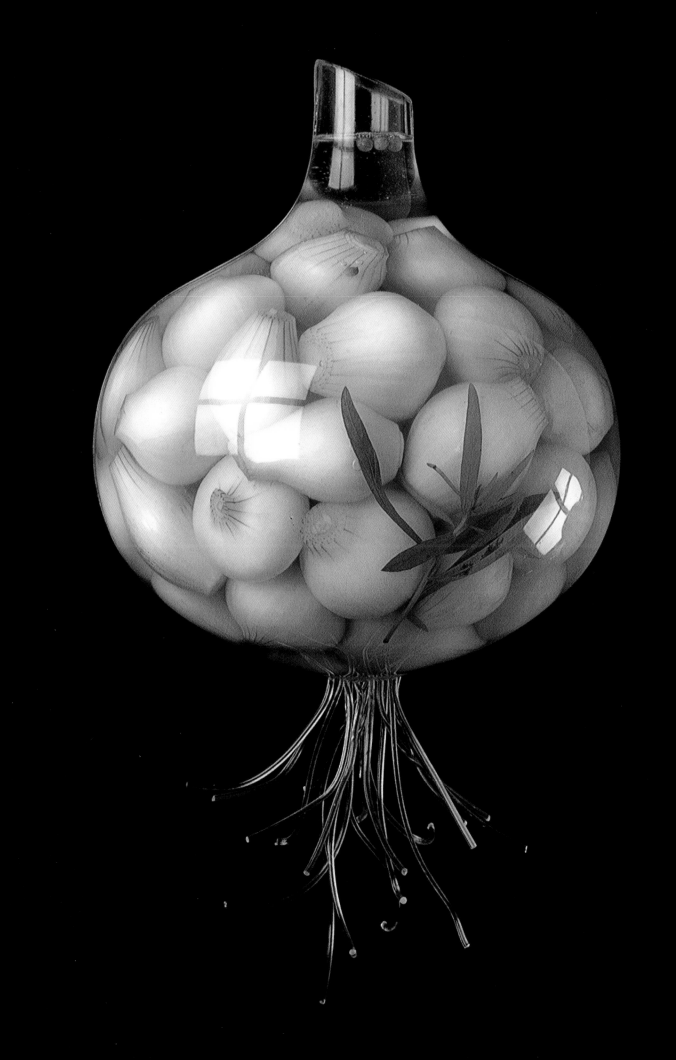

Evans spent a month in St Moritz on spec – and discovered horse racing on a frozen track. The picture was used in a winter sports number of the *Tatler*.
1965. Asahi Pentax
Kodak Tri-X Pan

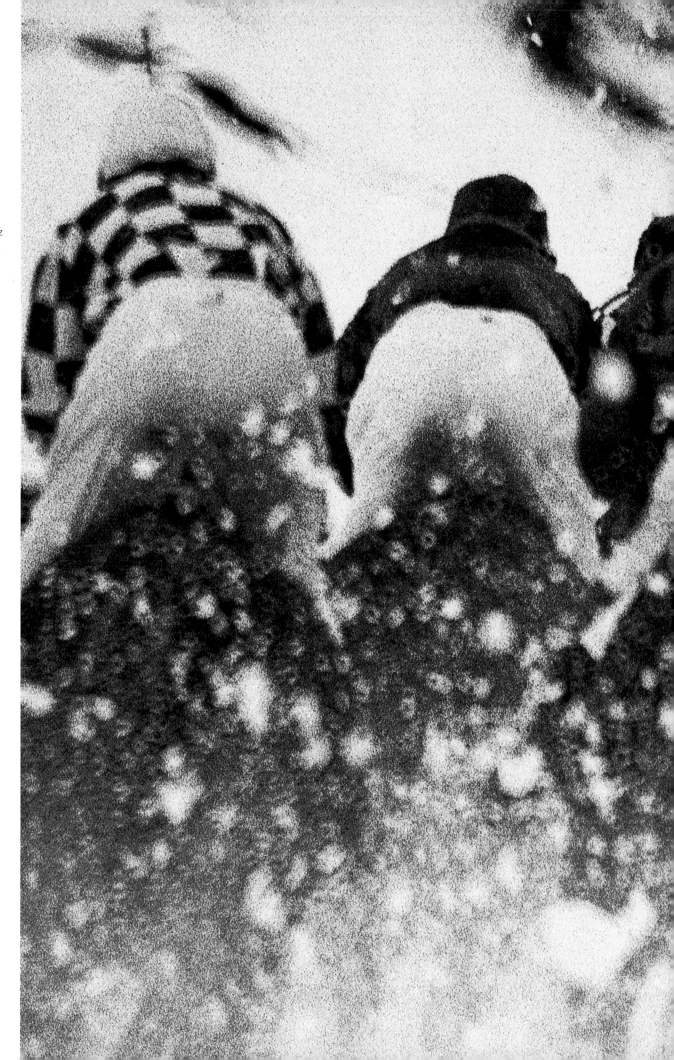

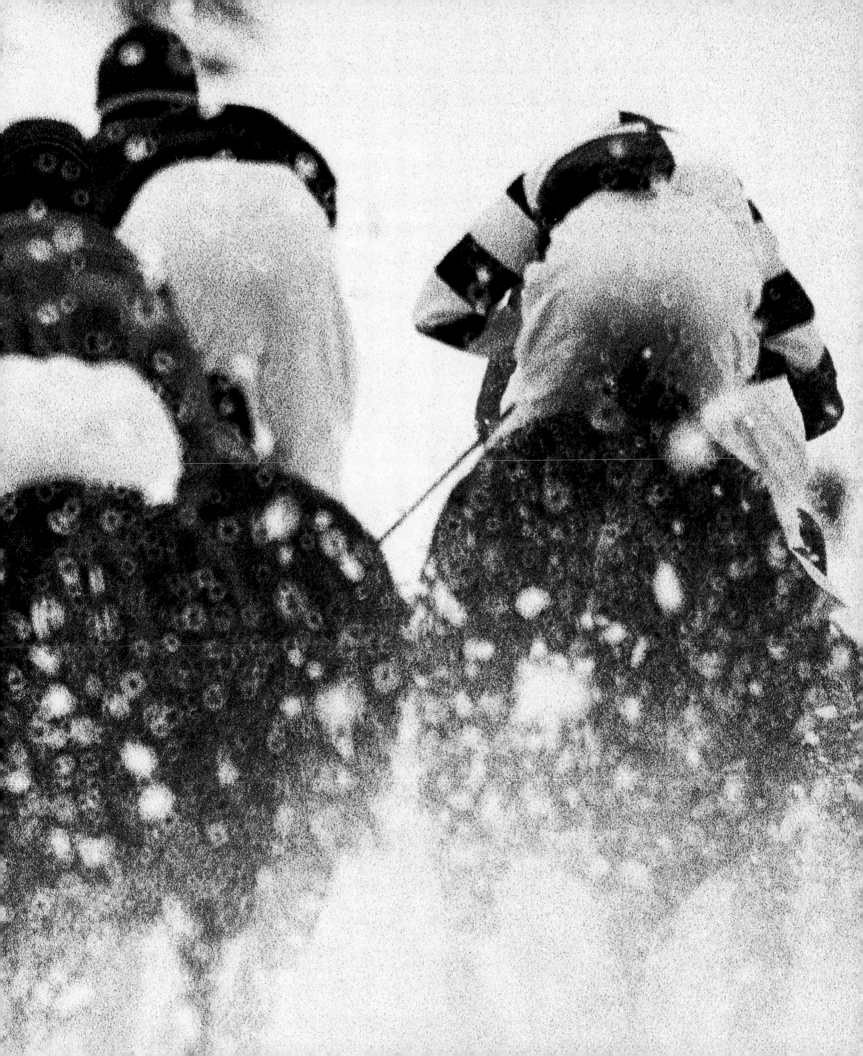

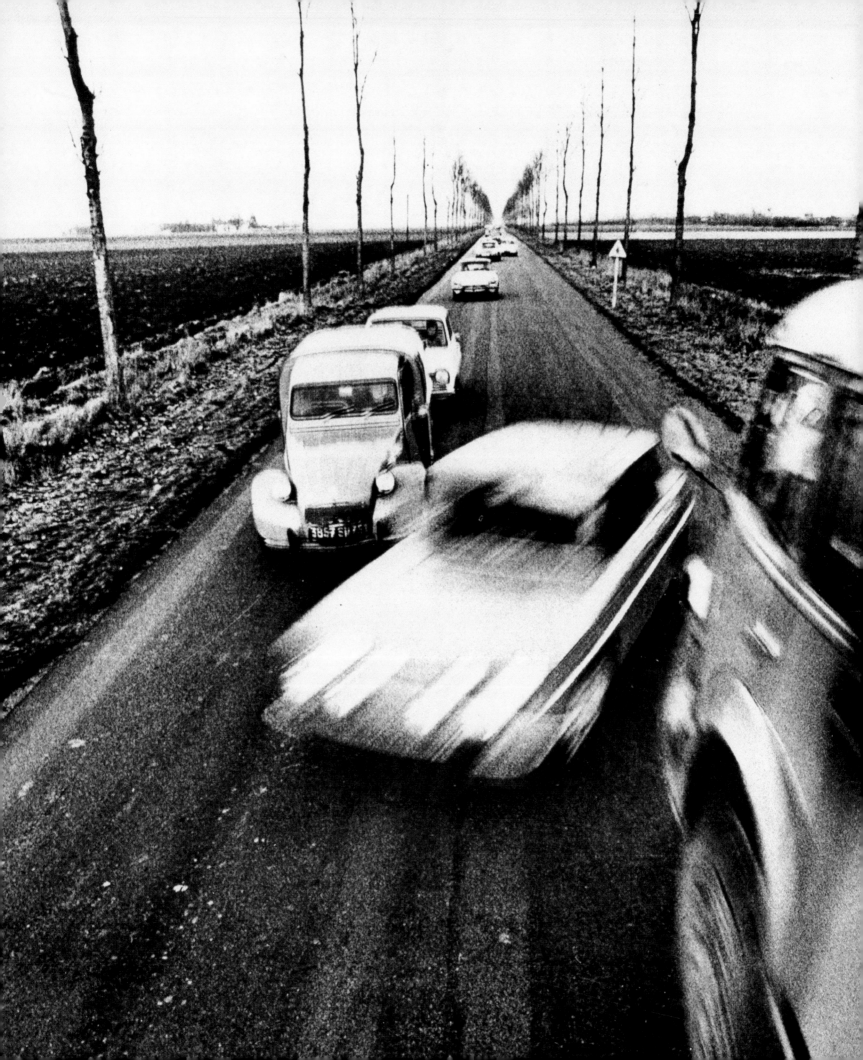

This Uniroyal advertisement (copyline: 'Don't let Big Feet go to your head) was a composite of three pictures taken in France: first, the road with traffic; second, the truck; third, the moving car. The three were stripped together and retouched by Phil Meyer to hair-raising effect. Art direction was by Martyn Walsh at the agency Doyle Dane Bernbach.
1968. Hasselblad
Kodak Tri-X Pan

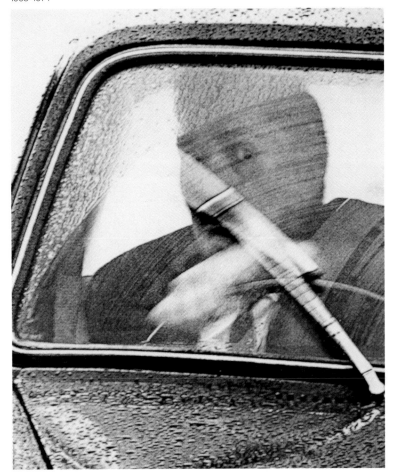

'Now that winter's over, the worst is to come,' from the award winning Uniroyal Rain Tyre series working with art director Doug Maxwell and copywriter David Abbott at the agency Doyle Dane Bernbach.
1968. Hasselblad
Kodak Tri-X Pan

The Uniroyal advertisement ('70 years late: the Rain Tyre') is two shots: one of the car and one of rain stripped in afterwards. The art director was Doug Maxwell and the agency Doyle Dane Bernbach.
1967. Hasselblad
Kodak Tri-X Pan

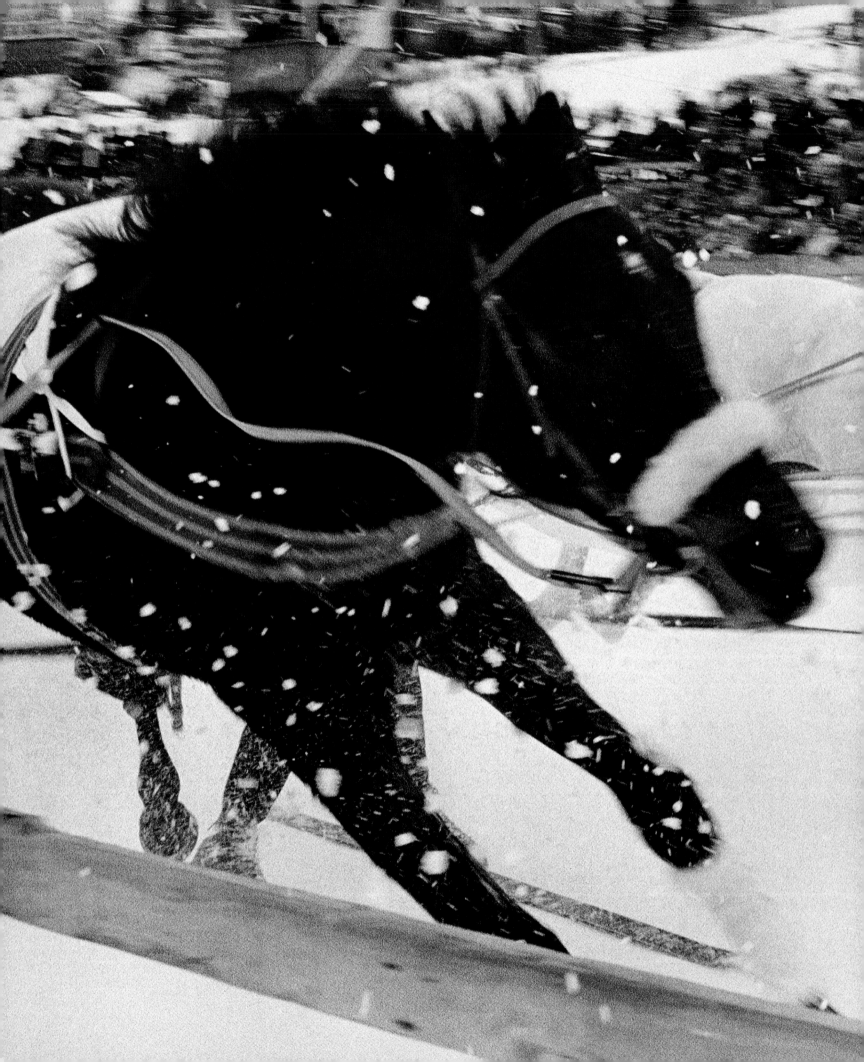

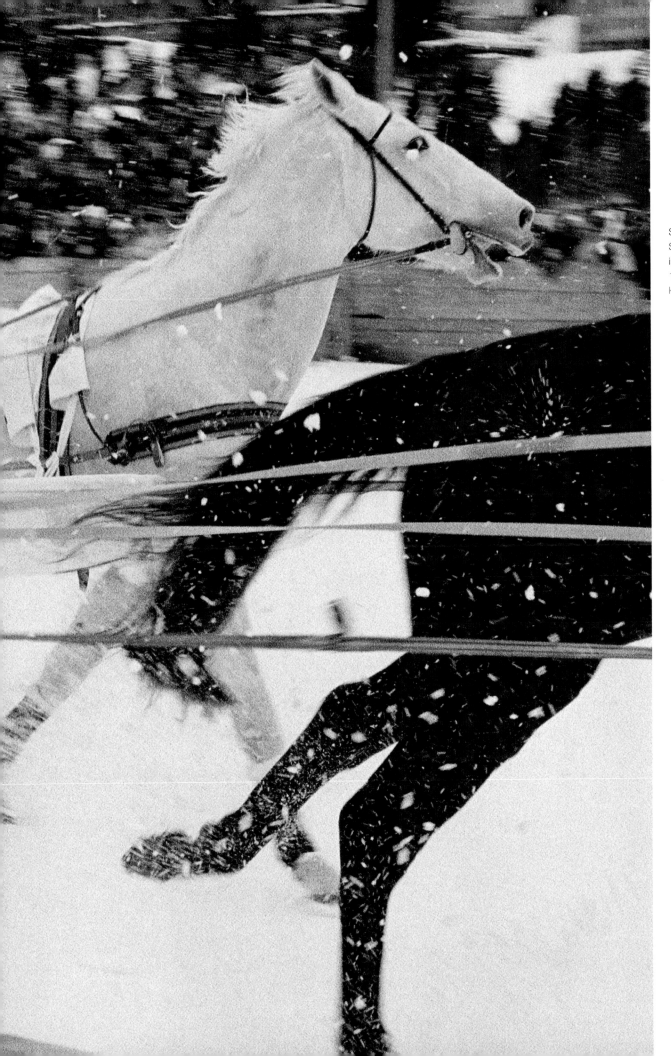

Sleigh racing, from a trip to
St Moritz in 1965, published
in *Tatler* (see also page 48).
1965. Asahi Pentax
Kodak Tri-X Pan

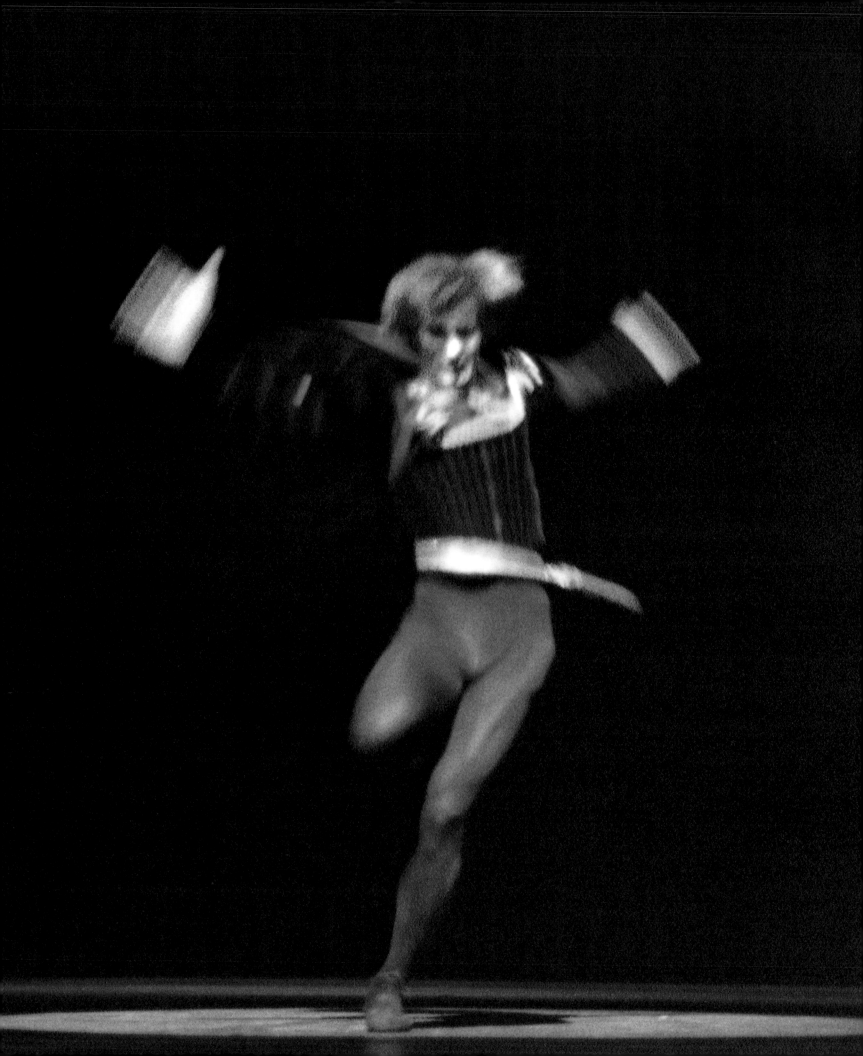

Rudolf Nureyev danced Hamlet and was photographed for *Tatler*.
1964. Camera and film unrecorded

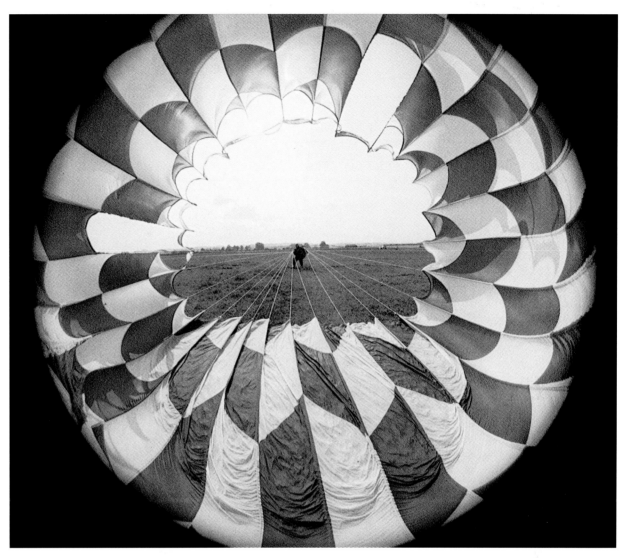

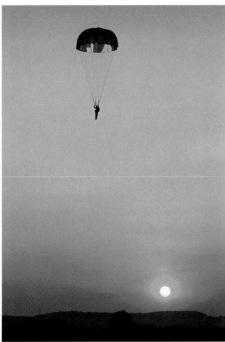

Most photographers in the Sixties aspired to work for the German style magazine *Twen* with its legendary art director Willy Fleckhaus. For these pictures of The British Parachute Championships, Evans first went up in a stunt Tiger Moth but the pilot turned out to be what he called 'a star graduate of the Bugs Bunny Flying School.' After that, he 'decided that there were some really good photographs to be had for the ground.'
1964. Asahi Pentax
Kodachrome and Ektachrome

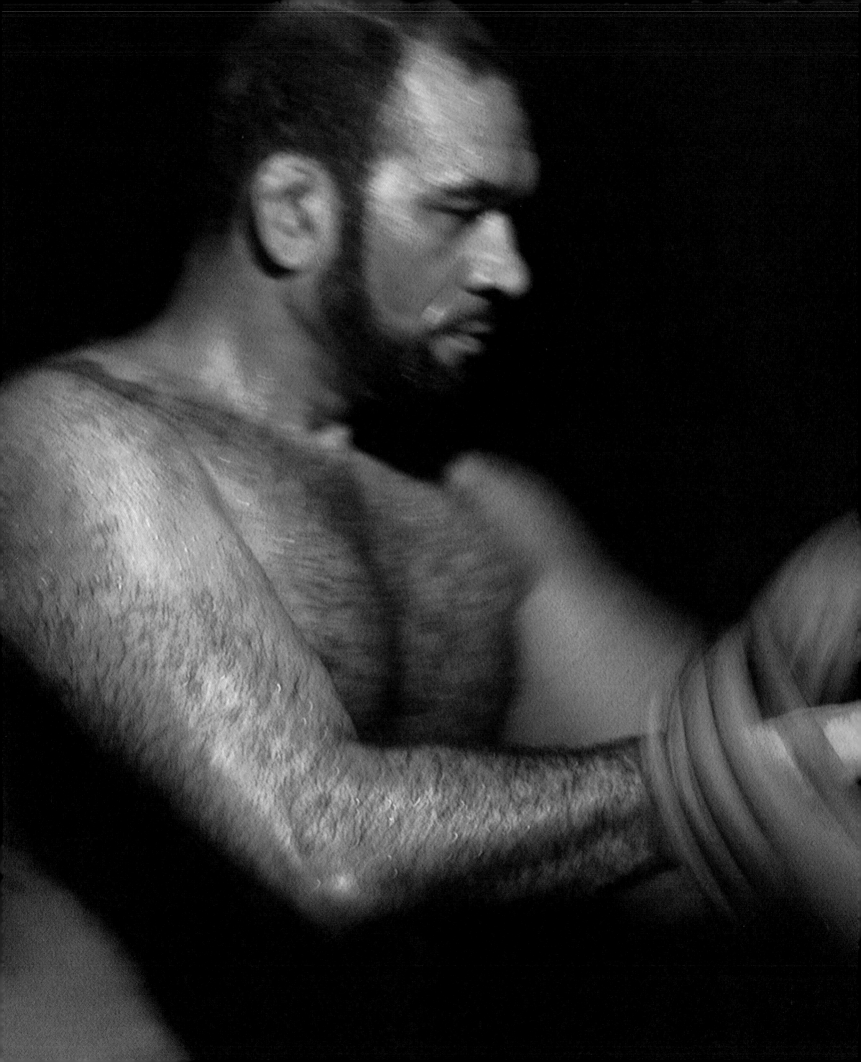

For a feature on India in BOAC's in-flight magazine *Welcome Aboard*, Indian wrestlers were photographed not in India but in Evans's London studio on Dartmouth Park Avenue. The art director was Robert Priest.
1970. Hasselblad
Kodak EHB

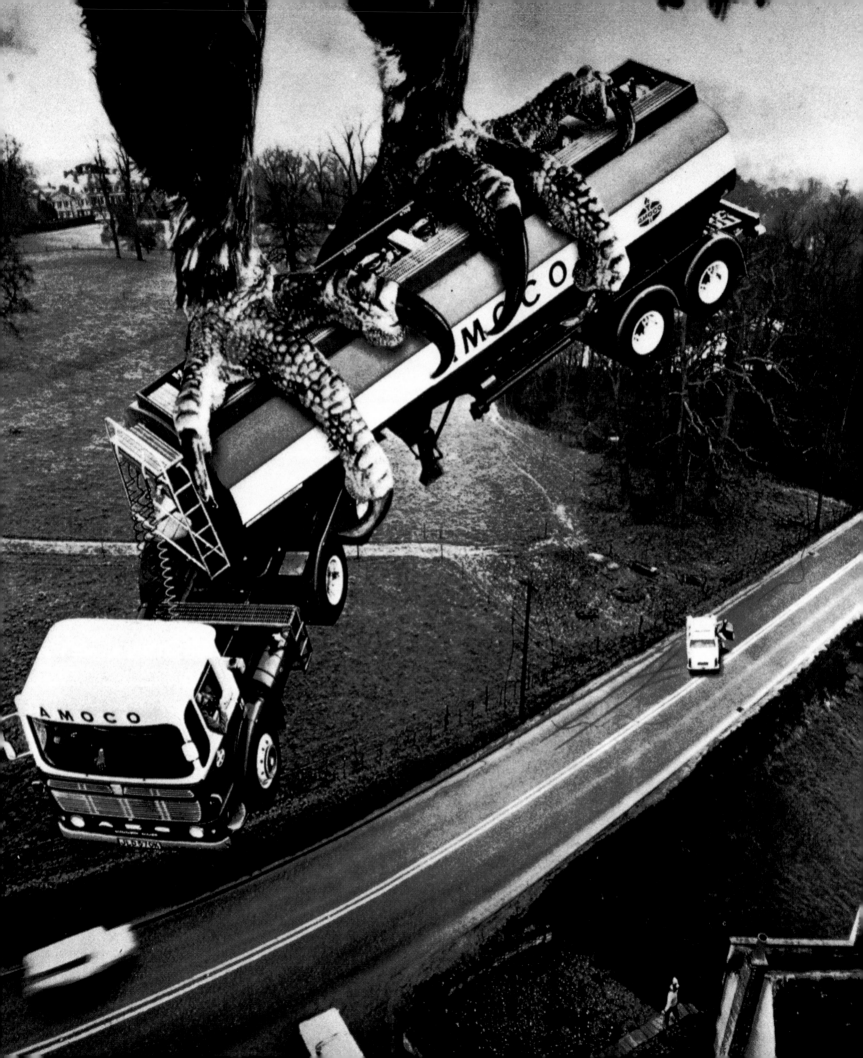

1972-1982

After living and working in a series of flats and studios in London, Tony Evans moved to a large detached Edwardian house in Dartmouth Park Avenue at the beginning of the 1970s. This became both family home and studio as his reputation as one of Britain's leading still-life photographers became fully established. Books began to add a new dimension to his work. He collaborated with Brian Rice on his first, The English Sunrise, published in 1972, which sold throughout the world inspiring a genre.

He spent six years on The Flowering of Britain with Richard Mabey, which was published in 1980, a project that opened his eyes to a gentler and more absorbing avenue for his work. He also collaborated with Candida Lycett Green on English Cottages, which was introduced by John Betjeman and published in 1982. Meanwhile, he had become one of the country's top editorial photographers, particularly for his work in the Sunday newspaper magazines, Nova and the Radio Times, and he also continued to produce work for the leading creative advertising agencies. His children Flora and James were born in 1974 and 1976.

Three shots were taken for this press advertisement: the background location from a 'cherry-picker', the tanker on a disused airfield, and a real live eagle in the studio. The retouching was done by Terry Potts, the art director was Bruce Gill and the agency C Vernon and Sons. The picture won a D&AD Special Citation in 1973. 1972. Hasselblad Kodak Tri-X Pan and Asahi Pentax Ilford FP4

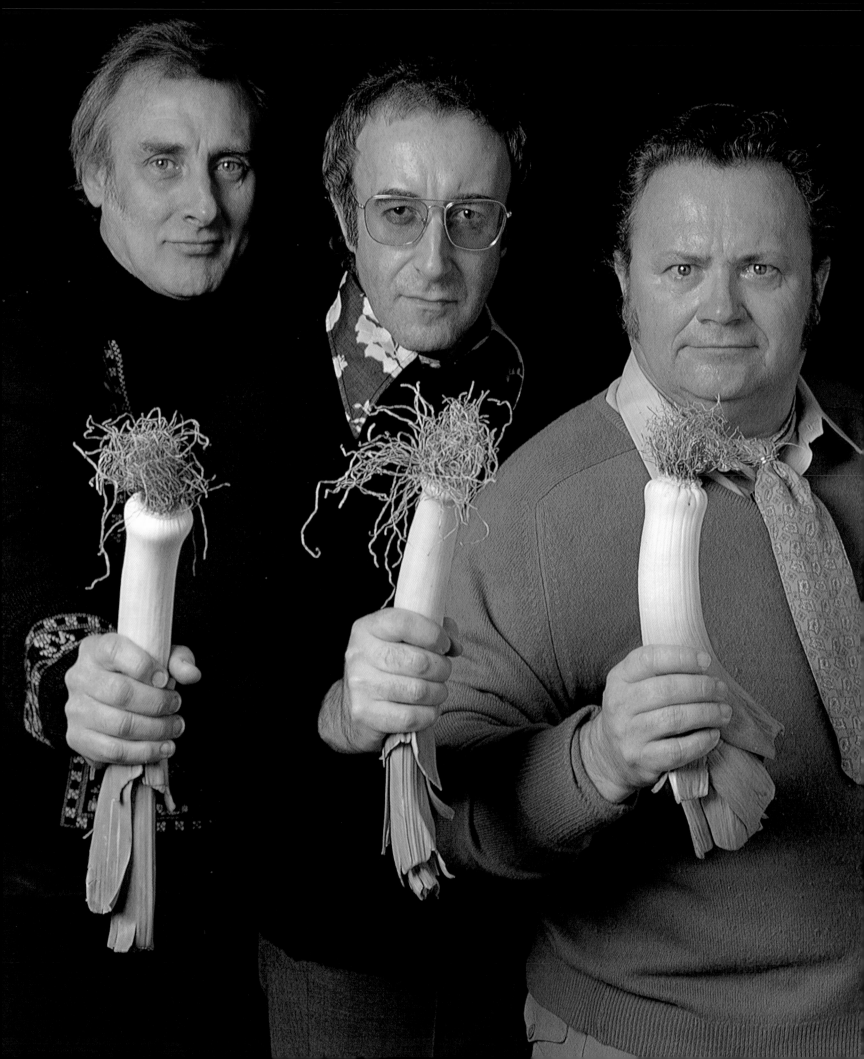

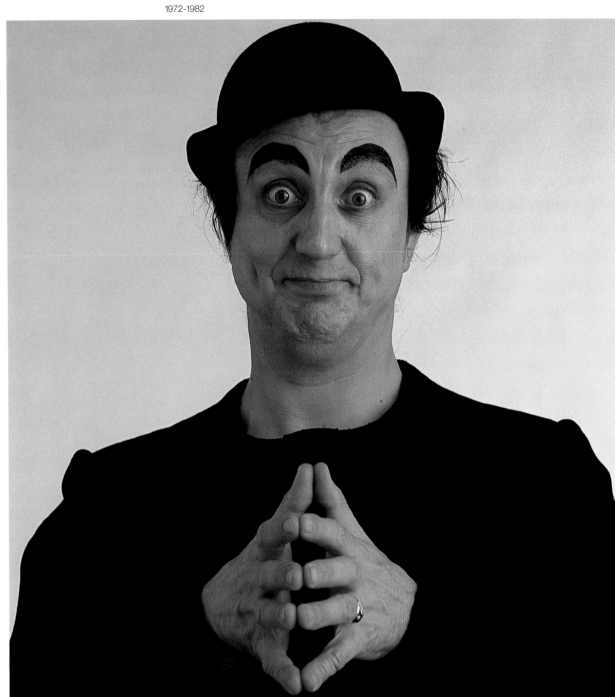

The Goons came together
for their historic last recording
at the Camden Theatre in April
1972 and were photographed
for the cover of the *Radio Times*.
1972. Hasselblad
Kodachrome

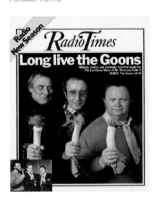

A studio portrait of Ken Dodd
as George Robey taken for
a *Radio Times* cover. David
Driver was art director.
1974. Hasselblad 150mm
Kodak Ektachrome

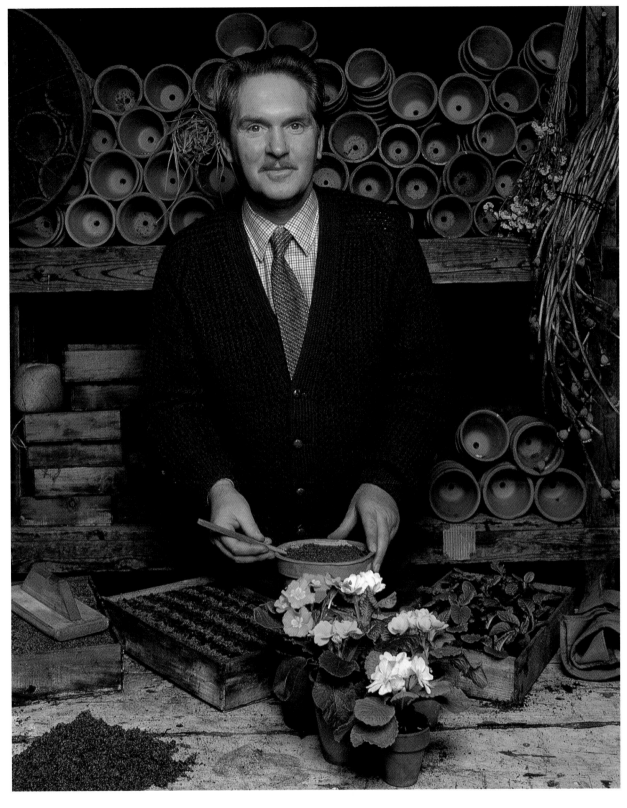

The 'green fingers' and portrait
of TV gardener Geoffrey Smith
were taken in his own garden
near Harrogate in Yorkshire
for a *Radio Times* feature, with
art direction by David Driver.
1978. Nikon 55mm Kodak
Ektachrome and Nikon 35mm
Kodachrome

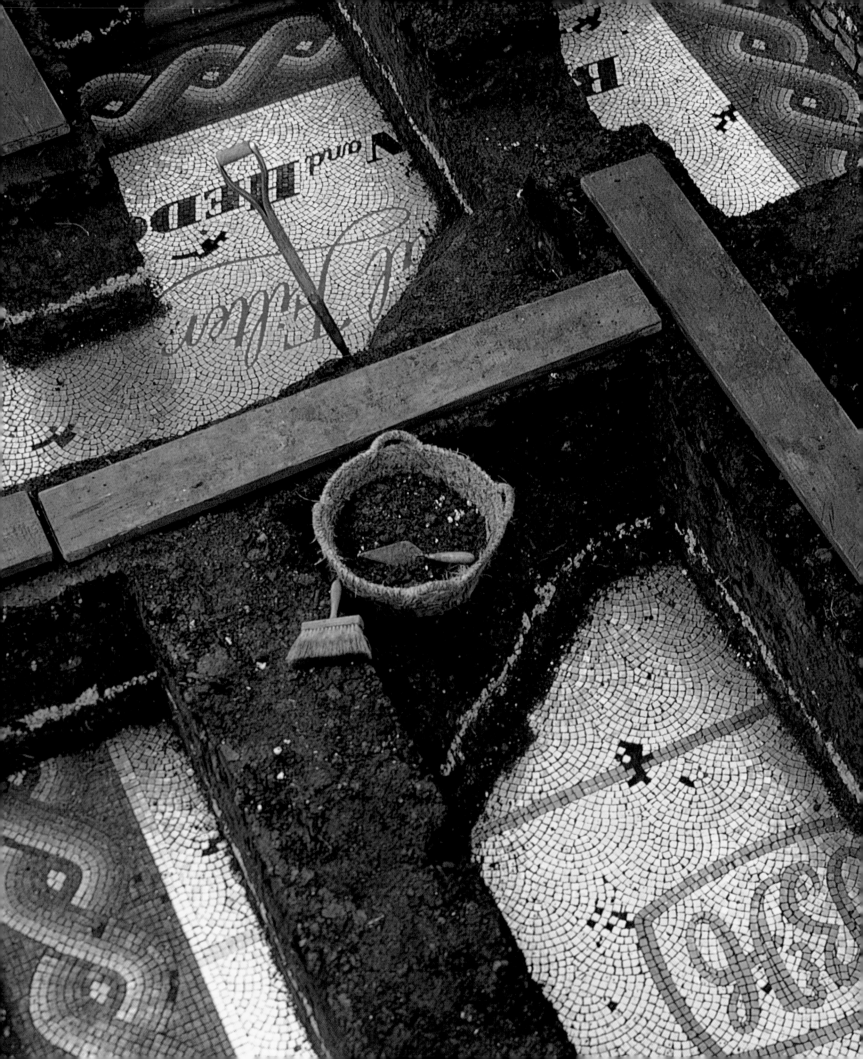

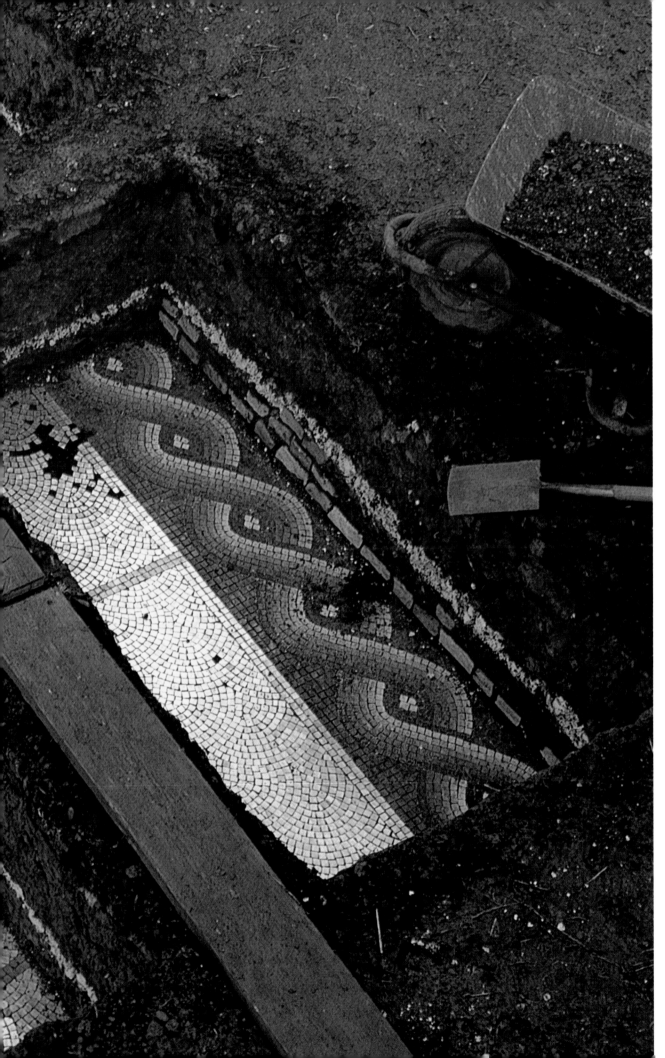

John Merriman, Collett Dickenson Pearce agency art director, had the idea for this Benson and Hedges advertisement after visiting an archaeological dig. The 10 x 8 ft mosaic was real, not painted. It was made by Guy Hodgkinson on his Suffolk farm and carefully dressed to look like an archaeological discovery. Taken in the December wet and sub-zero temperatures, the photograph was given a warm Mediterranean glow by shooting 30 ft up on a scaffold and using aluminium space blankets to reflect the natural light.
1981. Nikon 35mm
Kodachrome

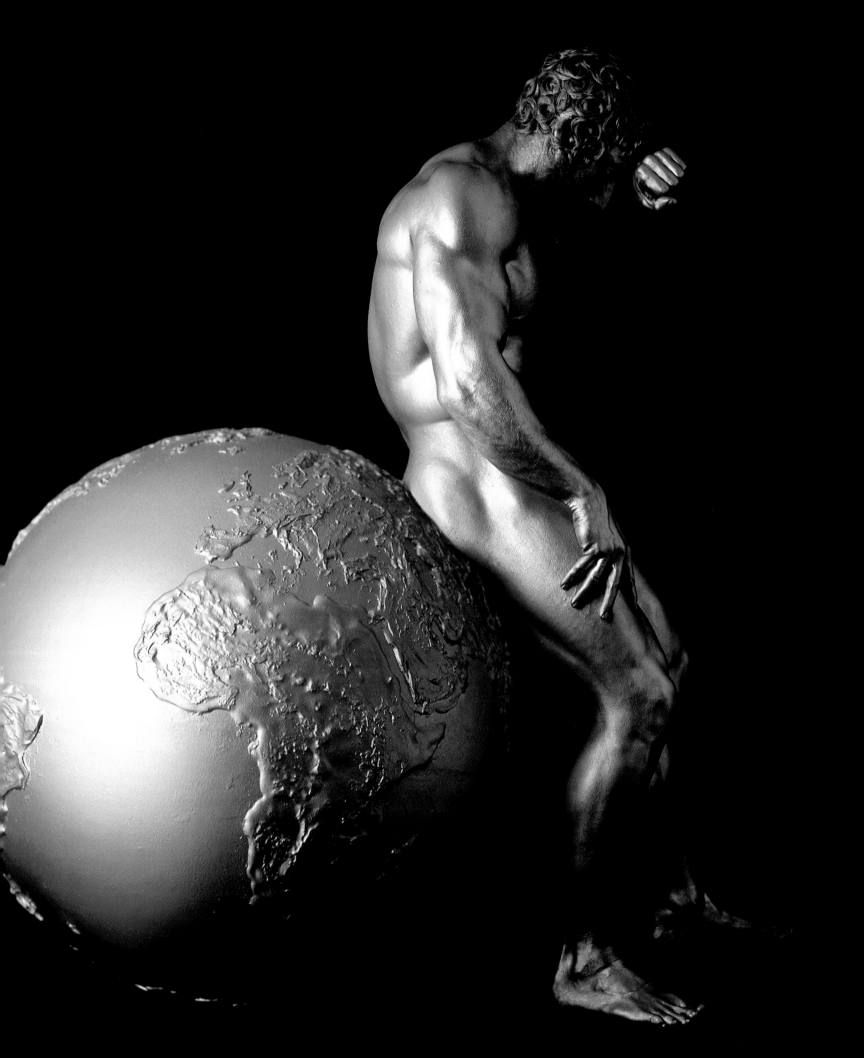

Cover and feature pages of a *Nova* article on the population explosion. The gold-painted bodybuilder Roy Parrot posed with a cut-out polystyrene disc in the studio. The globe, not to scale, was stripped into the space of the disc afterwards.
1972. Hasselblad 80mm
Kodak Ektachrome

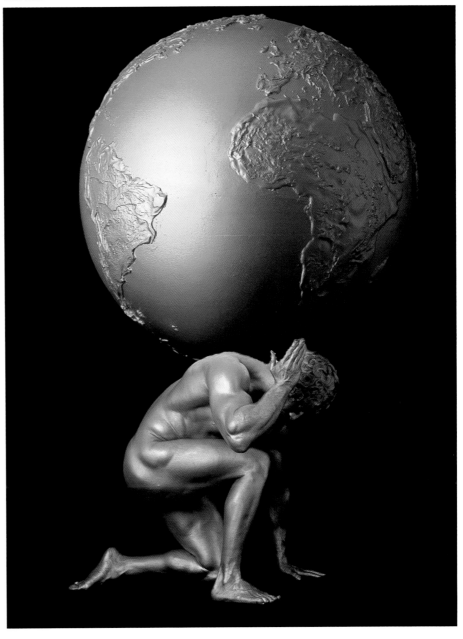

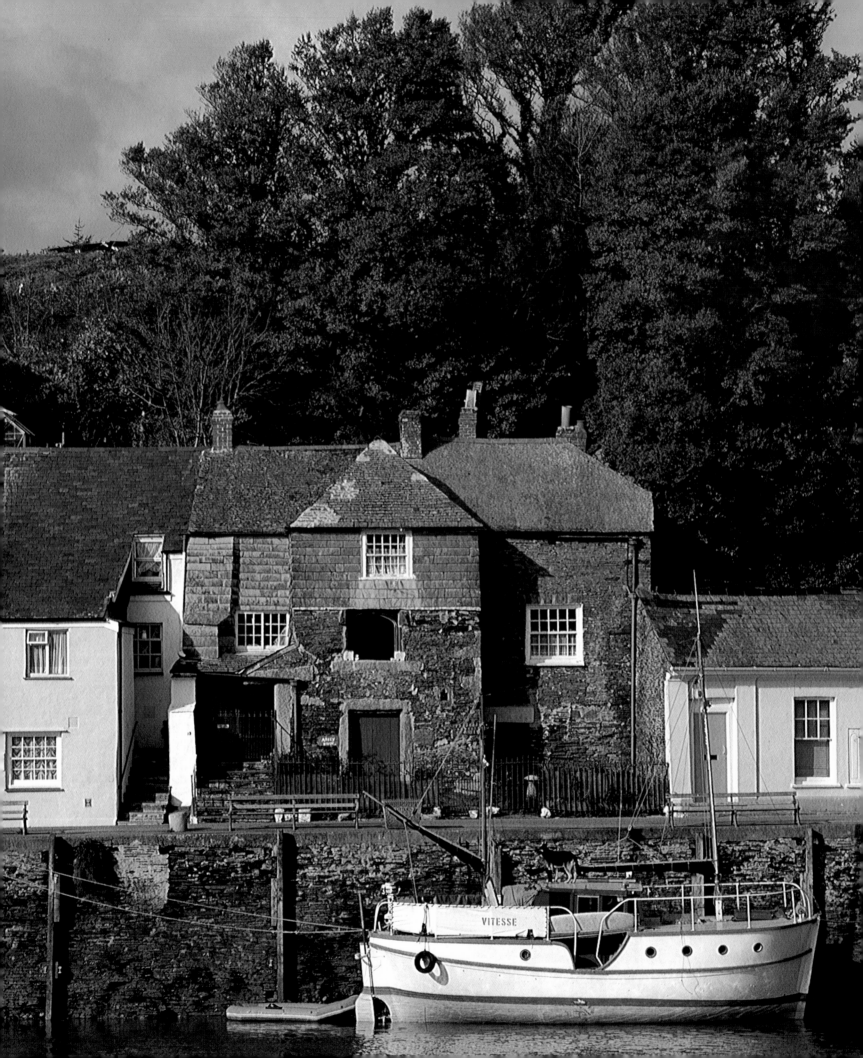

Candida Lycett Green is the
author of eleven books,
contributing editor to *Vogue*
and a television documentary
maker. She was a freelance
writer when she met Tony
Evans in 1981.

'He understood how time is here and now.'

Candida Lycett Green

Once we waited for a whole August afternoon, sitting
on a Dorset verge opposite a pair of thatched cottages,
waiting for a cloud. I couldn't believe it. There was
a perfect clear blue sky. Tony said it was 'too blue' and
that he had to have a cloud. By early evening, a three-hour
life talk later, the cloud had come and Tony then ran off
three whole films without changing the angle of the camera
and the shutter speed only once. That way he told me a
perfect print was guaranteed. It most certainly was.

When I first worked with him, he so neat and ordered,
I so messy and rushed, I thought we'd never last. I
was used to packing in a wild amount of scattered,
unsatisfactorily half finished jobs into each day and when
he reported back after a month on the road, that he had
only taken five of the thirty photographs I had hoped for,
my heart sunk. Our deadline for *English Cottages,* moved
ever further forward. Tony refused to take a photograph
unless the circumstances were right. He *knew,* and I didn't,
when a photograph would be good. The point is that *all*
Tony's photographs are good, he never took a bad one.

Once years afterwards I went to a famous publishing
house with an idea for a book and some sample
transparencies of A N Other photographer. The art

Padstow, Cornwall, from *English
Cottages*. Mark Boxer originally
commissioned Evans in 1981
just for the cover photograph
of the book, to be written by
Candida Lycett Green and
published by Weidenfeld &
Nicolson. As it turned out,
most of the year was spent on
the project when he was given
the whole book to do, working
closely with the author. *English
Cottages* was published in 1982.
1981. Mostly Nikon on
Kodachrome

editor looked through them and said 'There is not
one picture here that is a patch on any of Tony Evans's.'
English Cottages still sells well sixteen years later. In the
trade it's described as a 'sell on sight' book because
of how good it looks. Tony was insistent that we used
an outside art director, his friend John Gorham.
Weidenfeld & Nicolson baulked, it was unheard of in
an established publishing house to sub-contract and
besides it would cost an extra couple of grand. Luckily
the most enlightened editor of his generation, Mark Boxer,
backed Tony all the way and the book went ahead to
Tony and John's design. It began a style which was
subsequently copied for the 'English' series and has
been endlessly copied by other publishers.

Tony's perfectionism won the day. So did his company.
We laughed an inordinate amount. We never talked shop.
We discussed the point of life. He had this luxurious
attitude to time which I had never encountered before.
Days with him were pure pleasure. Over a summer,
we set off down one winding Sussex lane or across
Northumbrian moors to remote locations. If the weather
was fine, he would spread out a blue-and-white checked
table cloth on the grass and lay out with perfect meticu-
lousness, the bread and chocolate brownies which his
wife Caroline had made, the fruit and cheese, and he
would slice things very carefully with his penknife. It was
like a religious ritual. I loved it, it would iron out my flurry and

allow me to enjoy life in that minute. Tony never wasted time, he just used it perfectly. He looked as though he was doing things slowly but, because he did them so *well,* he was in the end an exemplary economist.

When he visited us for that last time as though to say good-bye, he brought his series of Iris photographs in their black box for a present. When I look at it today – the perfection of every detail from the tissue paper to the smooth touch of the card to the royal blue ribbon – it brings Tony winging back to that day when there was no sadness in his eyes. I'm sure it's because he understood so well how time is here and now. He brought with him that extraordinary and gentle calm which swept over us all. I realise now that he taught me, more than anyone else has ever been able to do, to be still.

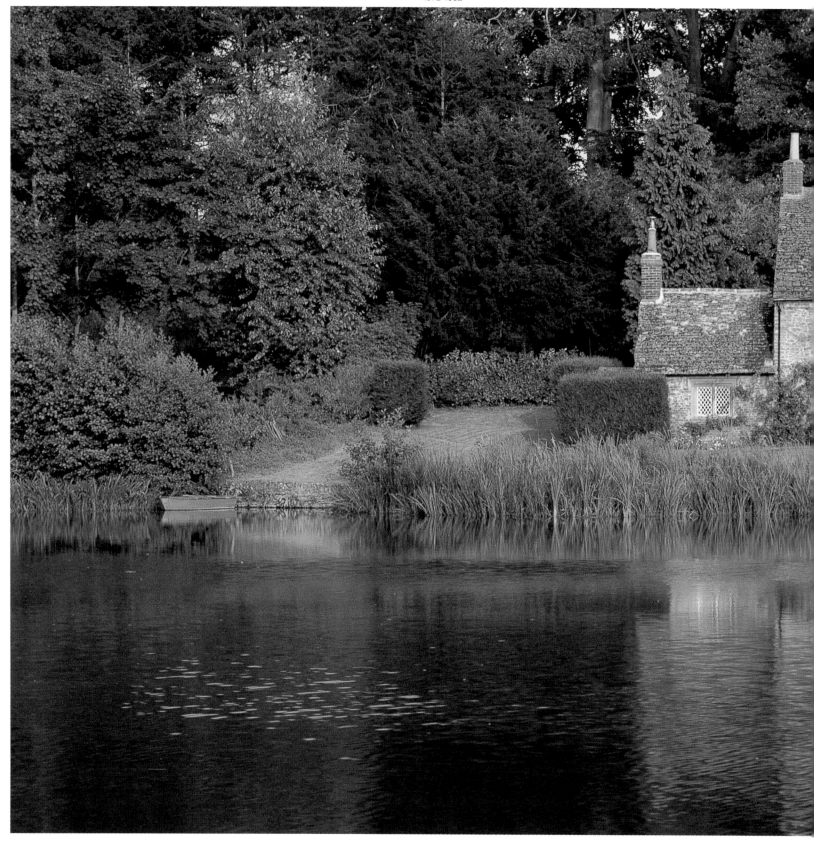

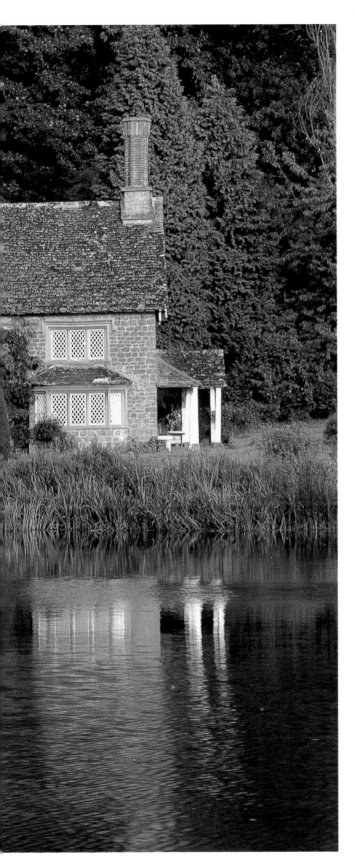

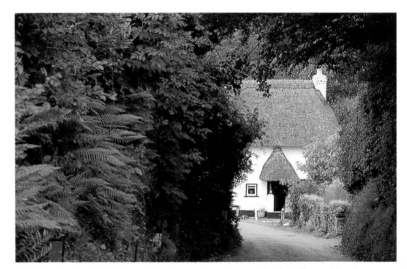

Harpford, Devonshire, from
English Cottages.
1981.

Bowood, Wiltshire, from
English Cottages.
1981.

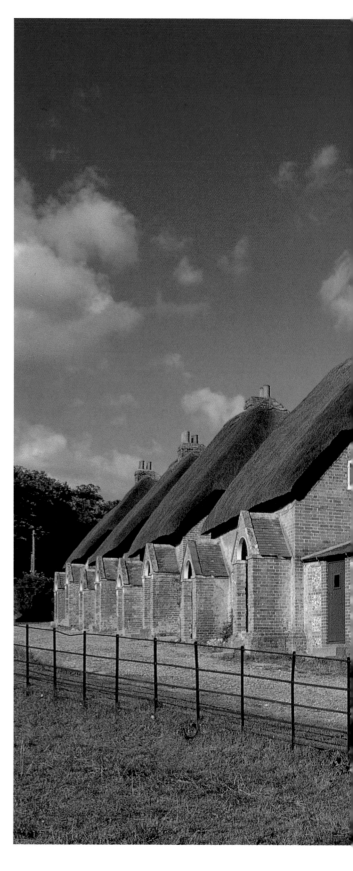

Clifton Hampden, Oxfordshire,
from *English Cottages*.
1981.

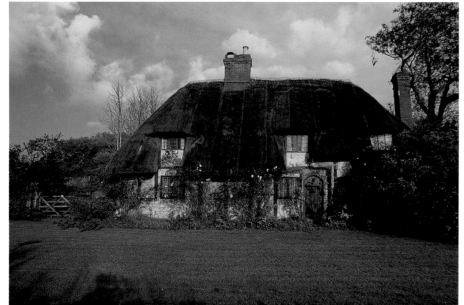

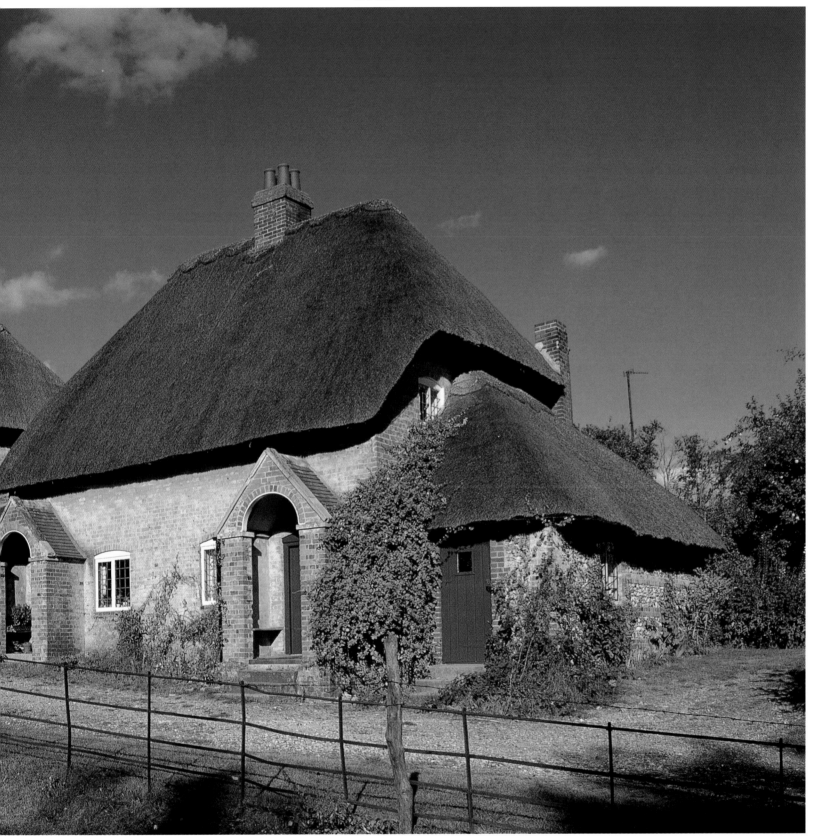

Leverton, Berkshire, from
English Cottages.
1981.

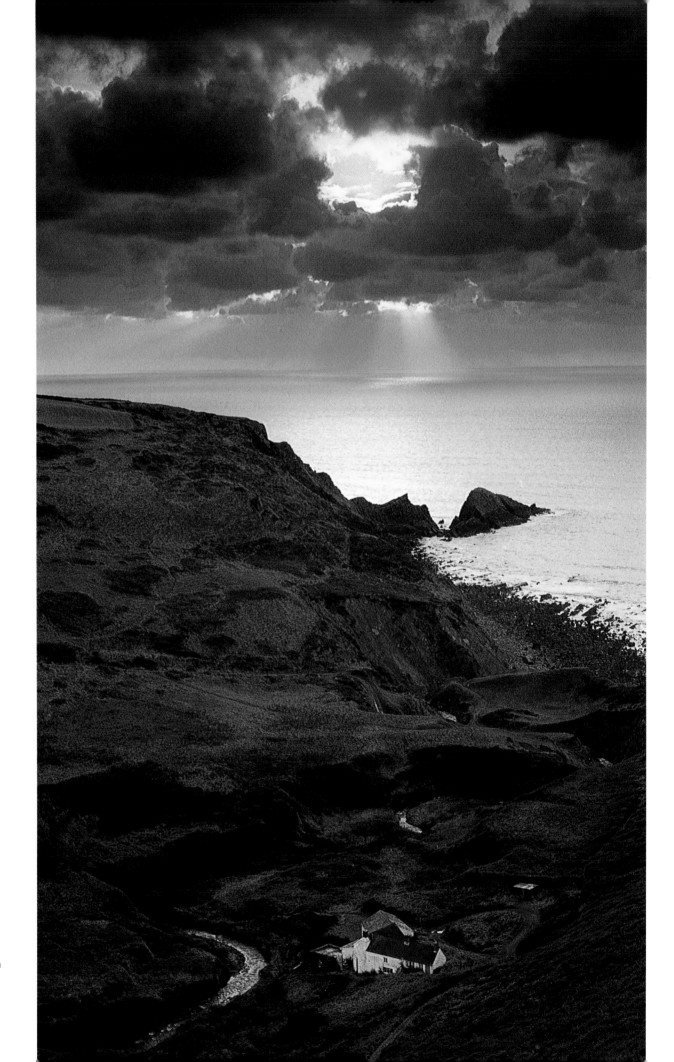

Welcombe, Devonshire, from
English Cottages.
1981.

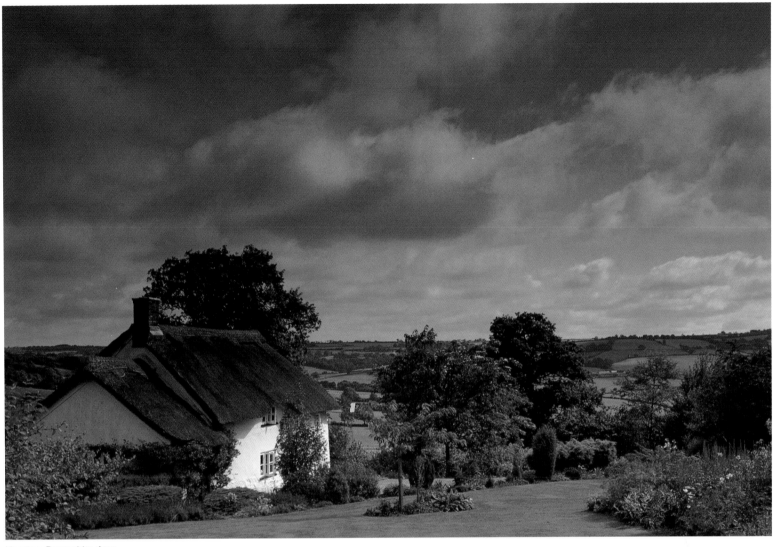

Upottery, Devonshire, from
English Cottages.
1981.

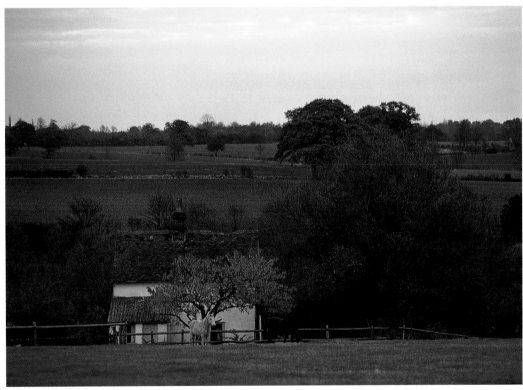

Braintree, Essex, from
English Cottages.
1981.

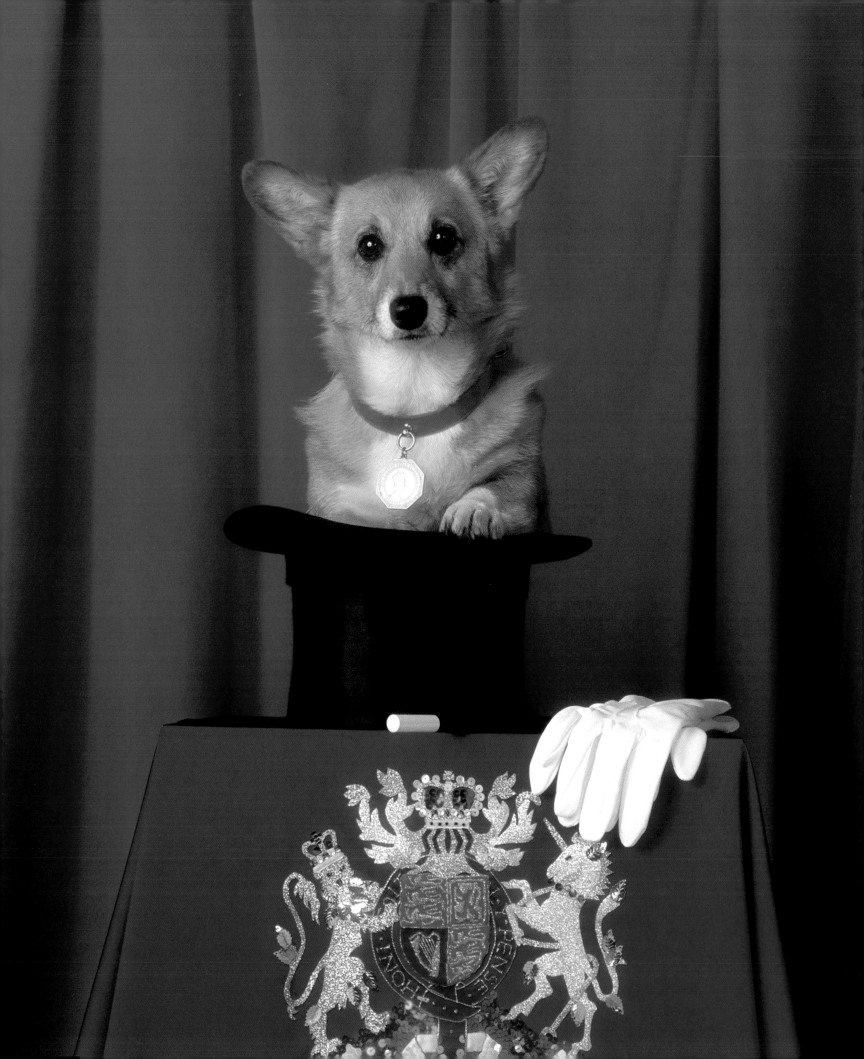

Russell Miller is a prize-winning freelance journalist and author. He first met Tony Evans on an assignment for the *Radio Times* and they subsequently often worked together for the *Radio Times, Nova* and the *Sunday Times Magazine.*

'He was always delightful; always maddening.'

Russell Miller

The year, I believe, was 1973. The assignment, for the *Radio Times,* was to fly to Moscow to interview and photograph Popov, the much-loved principal clown at the Moscow State Circus. The photographer was Tony Evans. Since at that time we had never met, I telephoned to ask him what he looked like so that I would recognise him at the airport. He seemed somewhat at a loss to describe himself, but told me not to worry: I could not miss him, because he would be wearing white clogs.

Thus it was, next day, I could be found at Heathrow's Terminal One, eyes down, searching for a pair of white clogs. When I eventually located them I found they were attached to a man it would be extremely hard to miss in the thickest crowd. Tony was wearing his standard uniform of jeans and denim shirt, but, more importantly, he had a shining bald head and a large beard.

In Moscow it quickly became clear that Tony was obsessive about getting precisely the picture he wanted. He decided he wanted a shot of Popov, in his clown garb, standing on his head outside the fine new arena that had been built specifically for the State Circus. Popov, who was no longer young, gamely obliged, wobbling somewhat alarmingly while Tony fiddled with his camera.

Many people's favourite Tony Evans editorial photograph is this *Radio Times* cover for the Royal Variety Performance, commissioned by Robert Priest. The pedigree Corgi's considerable official name was Mynthurst Albertine, but known as Bert to his friends. On the day of the broadcast, Celia Brayfield, in her TV programme guide in the *London Standard,* wrote '...the greatest entertainment potential in the event appears to be Tony Evans's witty cover photograph for the *Radio Times.*' 1976. Hasselblad 150mm Kodak Ektachrome

When I look back on it, it seemed to me the ageing clown was standing on his head for about 20 minutes, but I am sure in reality it was a much shorter period than that. However, when Tony at last professed himself to be satisfied, there was no mistaking the relief with which Popov regained his feet. He was in the process of shaking hands and bidding his farewells when Tony intervened. 'I'm sorry,' he said. 'You can't go yet. I haven't actually taken the picture. I've just been getting ready'.

Popov was not, perhaps understandably, pleased, but a few minutes later he was back standing on his head, purple faced, having succumbed to Tony's formidable charm.

Working in the Soviet Union in those days was a miserable business. We were accompanied every-where by a guide and interpreter, both KGB, who we subsequently discovered reported everything we did and said to their masters. This did not bother Tony so much as the complete non-availability of fresh fruit or vegetables and the dreadful service in restaurants. It was not unusual to wait for two hours between ordering a dish and actually receiving it, but Tony greatly relieved the boredom on our second night by producing from somewhere, to my utter astonishment, a Scrabble set. It became our routine to order dinner, then push the cutlery, plates and glasses to one side and embark on ferocious games of Scrabble. We never failed to

finish at least three or four games before the main course arrived.

Thereafter Tony and I worked together a lot. He was always delightful; always maddening. It seemed to me we were often missing return flights or ferries because of his insistence on finding just one more location, or taking just one more picture. On domestic assignments I would travel as a passenger in his VW camper. Am I dreaming or did he really have every Ordnance Survey map stacked in numerical order in a box between the front seats?

I remember years later, when he was staying with my wife and myself at our house in Buckinghamshire – at a time when he was obliged to swallow a daunting handful of pills every morning – he told us how he had waited four days for a single picture in the Lake District. He had wanted the sun to fall on a little white cottage on the other side of a lake at a certain angle and the surface of the lake to be unrippled and the clouds to arrange themselves to his satisfaction.

After four days, suddenly everything came right and Tony was just about to take his first picture when there was a low roar from just below the horizon and the Red Arrows screamed into view, trailing great plumes of coloured smoke across Tony's perfect sky. What did he do? He waited some more, until he got the picture he wanted.

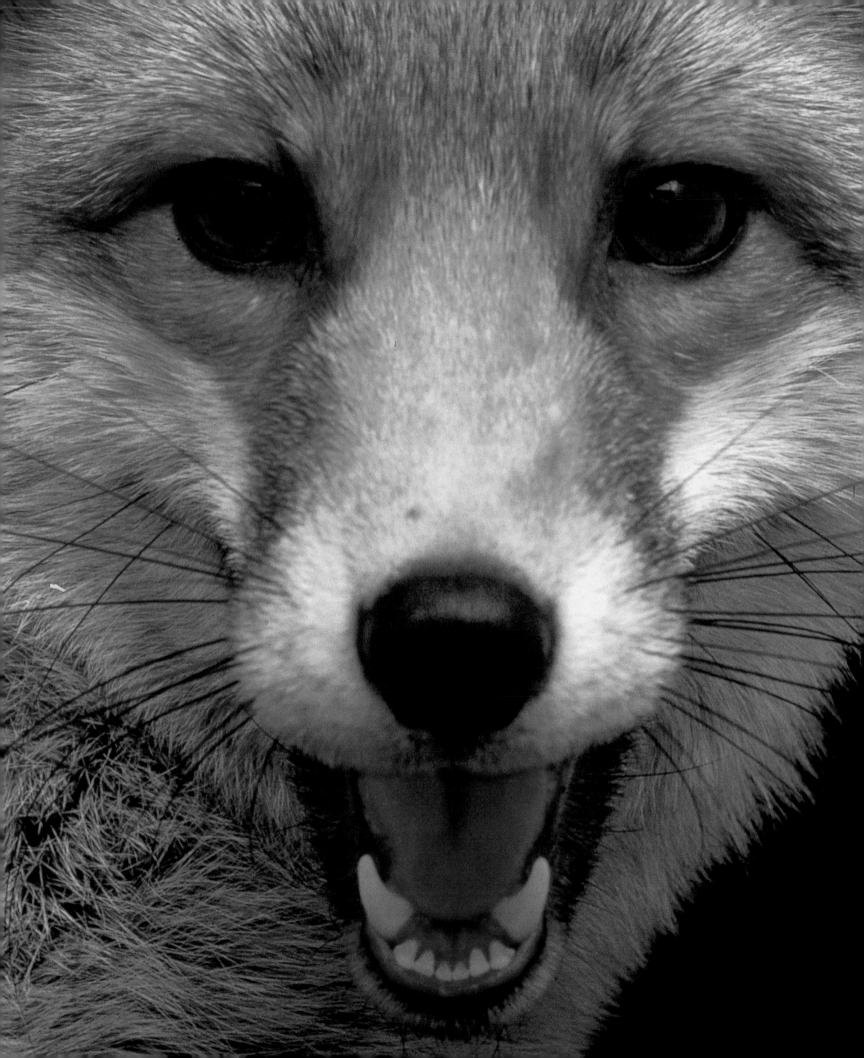

Will Red Rum make it three in a row? – the *Radio Times* cover for the 1975 Grand National. It didn't happen of course – he came second and the world had to wait until the following year for his extraordinary third win. The photograph was taken on the seaside at Southport, Lancashire, near the stables of trainer Donald McCain.
1975. Nikon 35mm
Kodak Ektachrome.

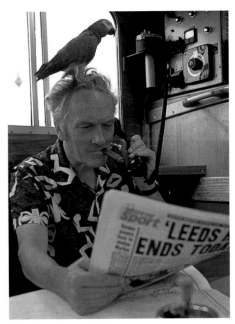

The ship's parrot perched on the powerful head of the IPC publishing empire, Sir Hugh Cudlipp, on board his boat *Alida*. For the *Radio Times*.
1973. Nikon 35mm
Kodachrome

Left.
The fox was called Flipper and was hired from the Animal Actors agency for the *Radio Times* cover on the 'Day of the Fox,' a programme in the Private Lives series.
1975. Hasselblad 150mm
Kodak Ektachrome

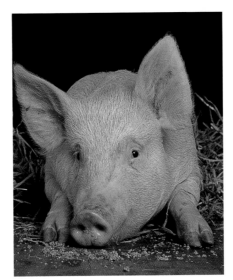

Radio Times cover for a Brass Tacks programme on pigs.
1977. Hasselblad
Kodak Ektachrome

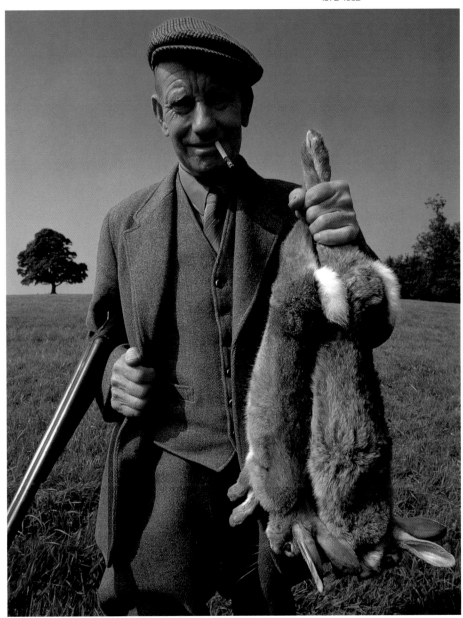

Leonard Longhurst, rabbit catcher turned gamekeeper. He had never had a holiday is his life, lived on less than £20 for a seven-day week, but nevertheless struck Evans as a 'cheery soul'. As he said: 'If I couldn't afford to eat meat one week I can always pop out and get a rabbit.' He was photographed as part of a major feature in *Nova* by Carolyn Faulder on rabbits, which spanned angora breeders to Playboy Bunny Girls (see also page 96/97).
1973. Nikon
Kodachrome

Radio Times cover photograph of Tryggve Gran, Nowegian champion skier and youngest member of Scott's fateful Antarctic expedition – he was in the back-up party that discovered the body in 1912.
1972. Nikon
Kodachrome

Left.
Dr Jacob Bronowski, with his daughter's Borzoi, photographed on his marigold lawn near where he worked at the Salk Institute in La Jolla, California. The *Radio Times* cover heralded the formidable 'Ascent of Man' documentary series written and fronted by Bronowski.
1973. Nikon 35mm
Kodachrome

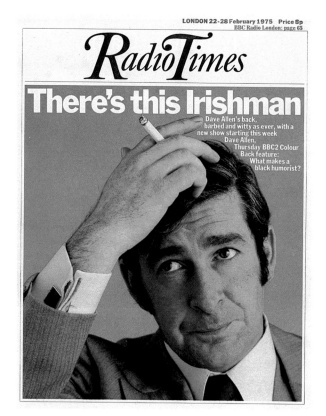

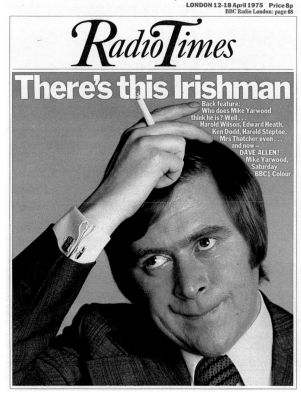

The Dave Allen *Radio Times* cover photograph was taken in the studio in November 1974. The portrait was revisited by Evans for his Mike Yarwood cover, published a couple of months later and photographed in February 1975 at the Opera House in Manchester where Yarwood was performing.

1974 & 1975.

Hasselblad 150mm

Kodak Ektachrome

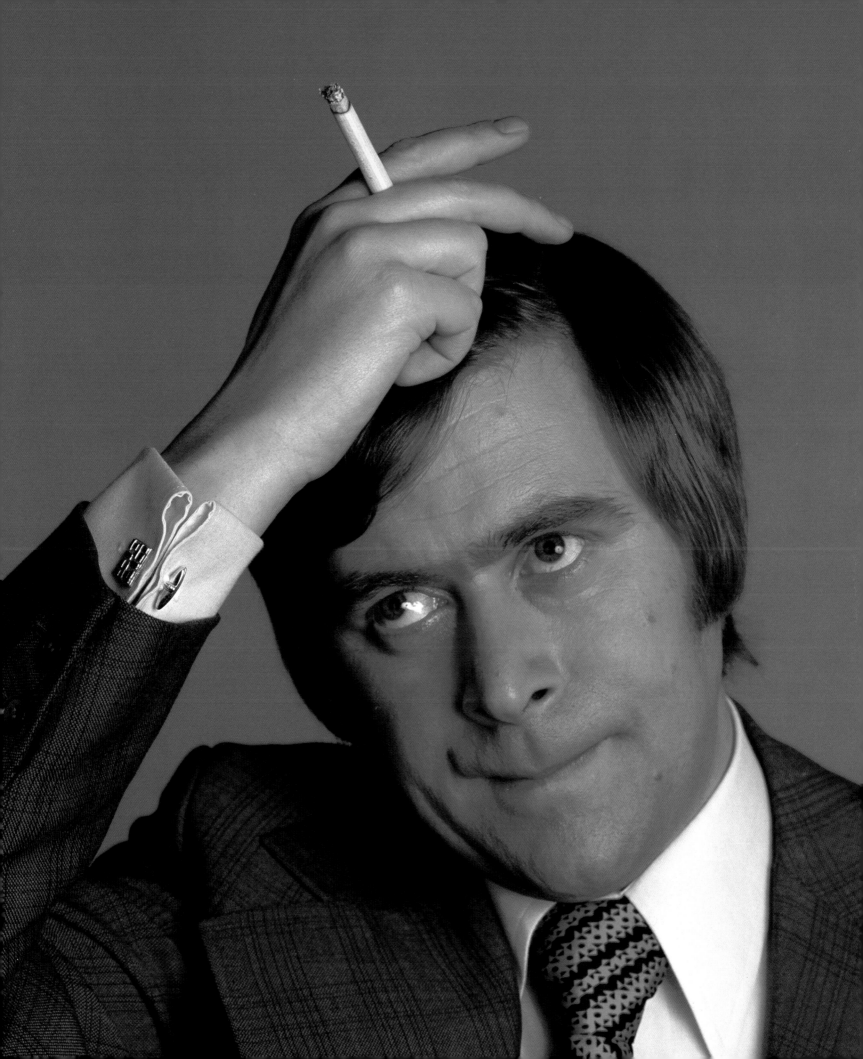

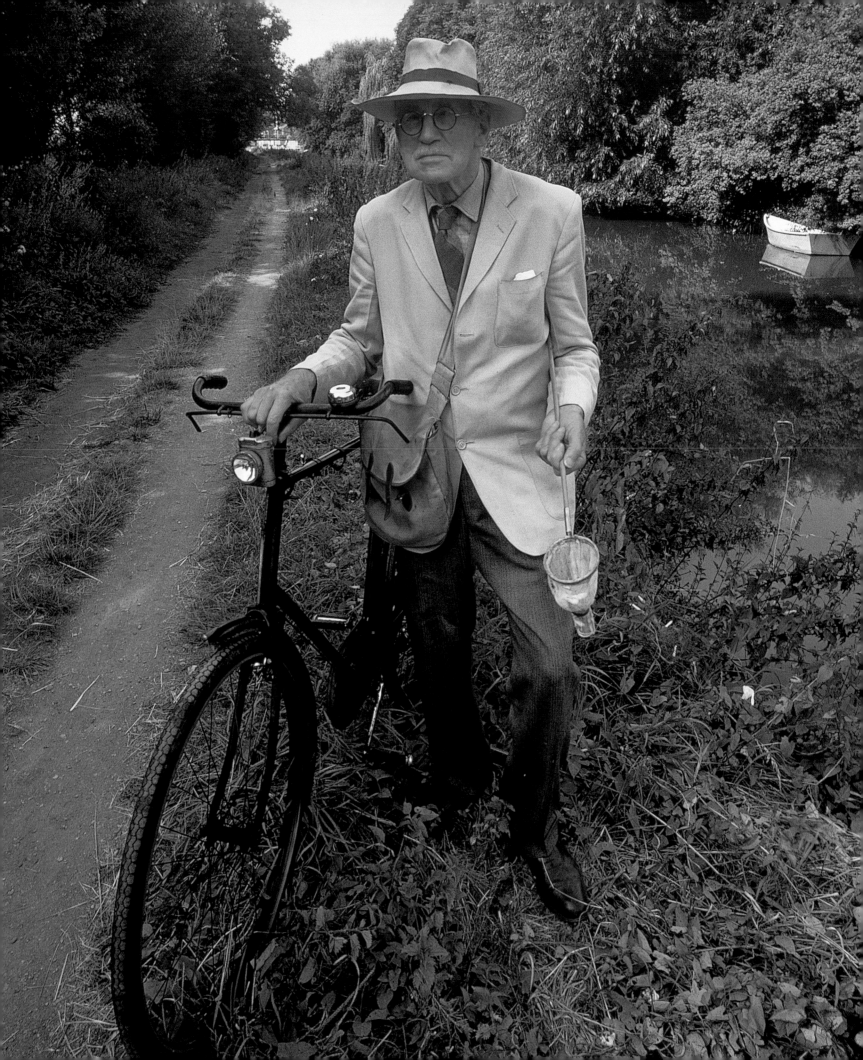

Phillip Norman, novelist and
biographer, became a close friend
of Tony Evans after working with
him on assignments for the *Sunday
Times Magazine.*

'Tony loaded me up like a pack mule.'

Phillip Norman

During 1968 I spent long hours sitting in a gloomy, over-heated office at the rear of the *Sunday Times'* old Gray's Inn Road building. I was supposed to be a feature-writer on its colour magazine, but could get no one to accept my ideas or – it often seemed – even to remember my existence. From time to time the door would open and a man would look in and say 'Hello.' Though only two or three years my senior, he was already totally bald. He wore a Chinese-looking goatee beard, brown herringbone trousers and highly-polished platform brogues. His voice had the sibilant mildness of a Quaker elder. In my demoralised state, I could not understand why he kept being so nice to me.

On the magazine's starry roster of photographers – Snowdon, Bailey, McCullin, Donovan – Tony Evans was then just a supporting name. He had been hired to take pictures for the design and cookery pages whose female editor was a sometime inhabitant of my backwoods office. He would go off and photograph things like Fabergé eggs and Victorian chocolate boxes. The painstakingly perfect studies he produced were often elbowed aside by sexier spreads from Vietnam, Biafra or the American South. We became friends from

Sir Alistair Hardy, Professor of
Zoology at Oxford, photographed
for cover of the *Sunday Times
Magazine.* Evans wrote: 'At the
time he was writing a book about
life in ponds, pools and puddles
and I wanted to photograph him
near water. Fortunately, there
was this delightful canal near
his home in Oxford and he was
willing to wheel his bicycle there.'
1976. Nikon
Kodachrome

being in much the same boat: both persevering against the odds.

Our first assignment together was in Switzerland, covering the shoot of a BBC2 film about Wagner and the Siegfried Idyll. On the journey, Tony loaded me up like a pack mule with his photographic equipment, but he was so polite and pleasant and charming – and funny in that soft-voiced way of his – that I couldn't find it in my heart to object.

It was on our Wagner story that I first beheld the almost supernatural care and precision of Tony's working methods. The principal object to be photographed was Wagner's mildewed black velvet smoking jacket. It took Tony most of the day, augmenting the paraphernalia we had lugged from England with background drapes, a steam kettle and sheets of coloured paper which he did not buy but somehow borrowed from local shops. By the end of that afternoon, the museum's female curator might have been thought ready to hurl us off the premises. Instead, such was Tony's charm, she invited us upstairs to her flat for cheese fondue.

We followed the Wagner story with one about Berlioz, travelling to photograph his smoking jacket at even greater length in Côte St André. We stayed in a hotel where two Siamese cats ran around the outside parapet: when I descended to the bar for breakfast each day, both of them would be sharing Tony's breakfast. From

there we went on to Zug in Switzerland to do a story on a man named Boris Hagelin, an inventor of coding machines. I remember standing on a snow-flurried Swiss railway station, loaded down with Tony's tripod and lights, while he told me about photographing the Blues singer Big Joe Williams. I can see his goatee-bearded face now, and hear him imitating the Bluesman's voice, saying 'I'm sure 'bliged....'

Oh, and I almost forgot the other funny little habit he had at the beginning of a story. He'd ask you to donate some of your expense-money so that he'd have greater funds at his disposal for hiring steam kettles and background velvet for still-life shots. In the pursuit of the definitive shot of Wagner's smoking-jacket, who could refuse him.

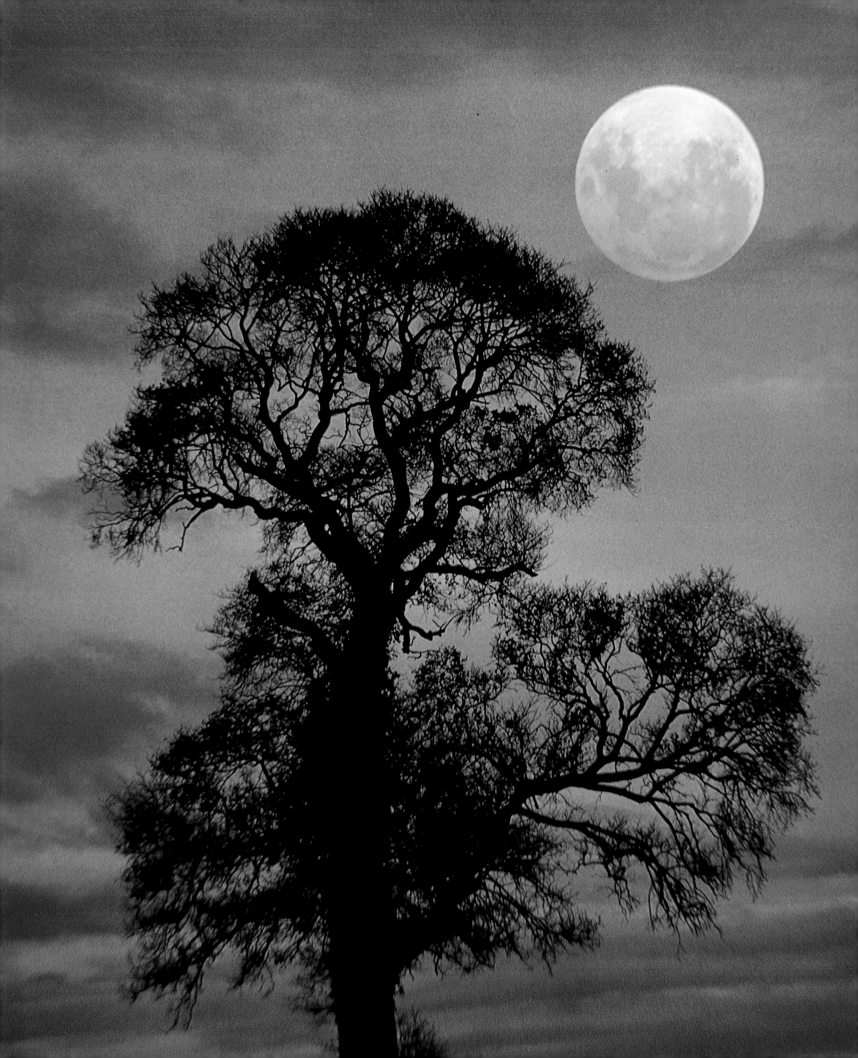

Left.

'This is one of the very few natural history photographs which I pre-visualised. I wanted to do a picture illustrating the death of the English elm.' It took ages for Evans to find a suitable tree. Then cloud stymied him on the first two opportunities and, with only one chance a month to get what he wanted, he didn't like the look of the odds. 'So I shot the tree as it was, came back to London and photographed the moon that same evening, then double exposed the two images onto one film.' The photograph was taken for the cover of *Epitaph for the Elm*, published by Arrow Books. It was also used for the front cover of the *Sunday Times Magazine,* the front cover of *Origine* in France and in *L'Europeo* magazine.

1978. Nikon
Kodachrome

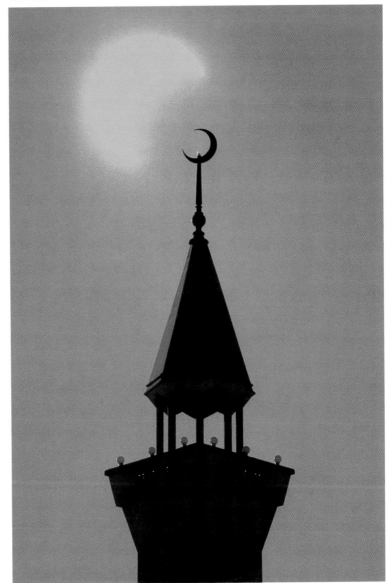

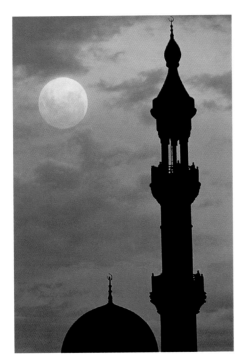

A promotional calendar, conceived and designed by Alan Fletcher at Pentagram for the Commercial Bank of Kuwait, had Evans photographing 12 mosques in the parched Gulf state. He noted that a partial eclipse of the sun was due in February 1980 and extended his stay to capture the suitably crescent effect for one of the pictures (*above*).

1980. Nikon 35mm, 55mm and Vivitar Zoom
Kodachrome

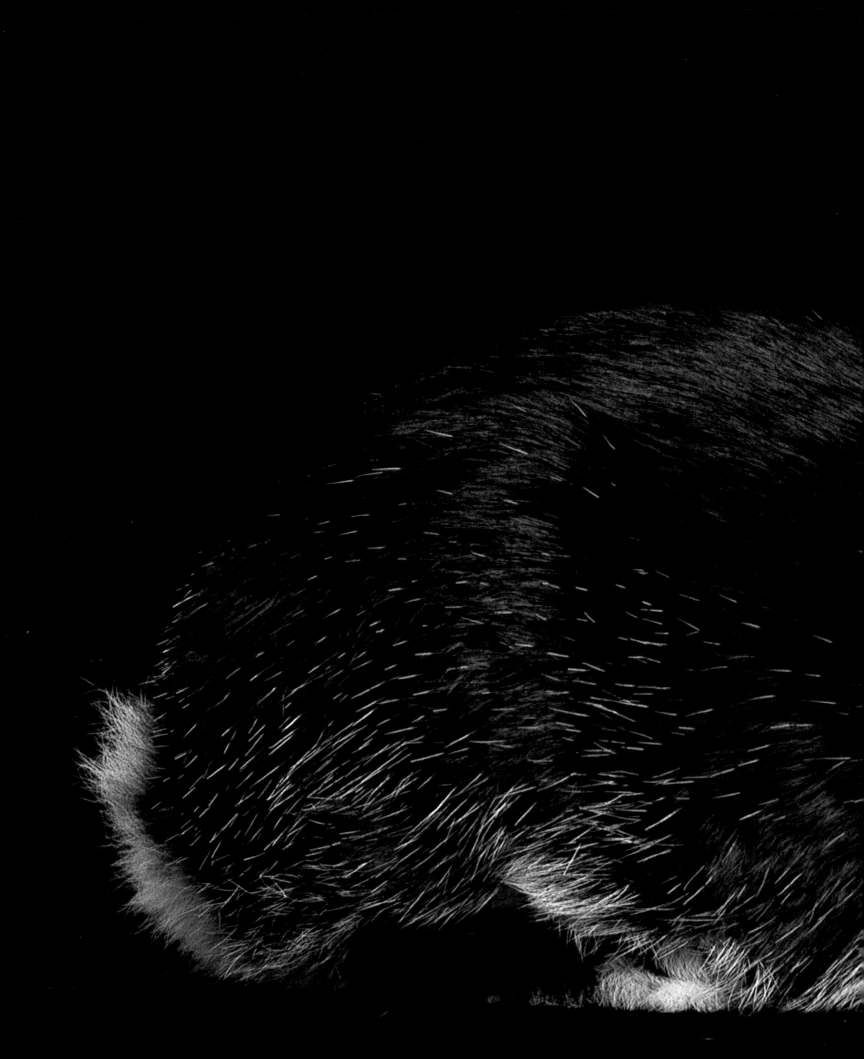

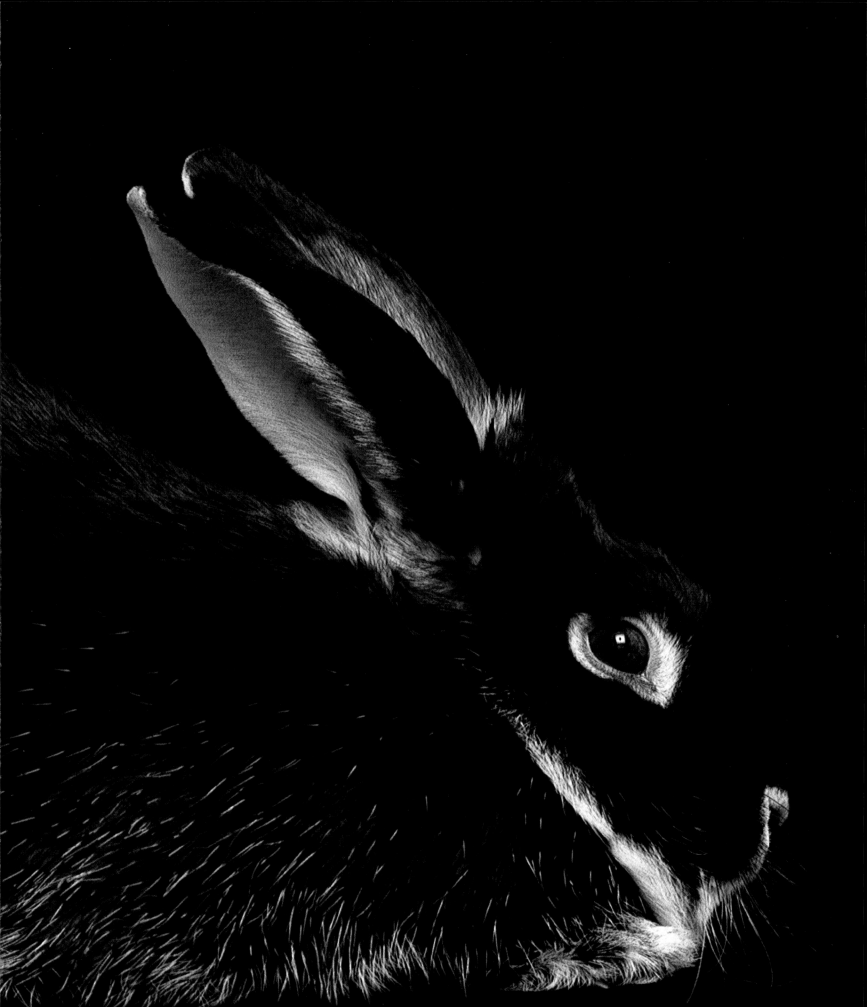

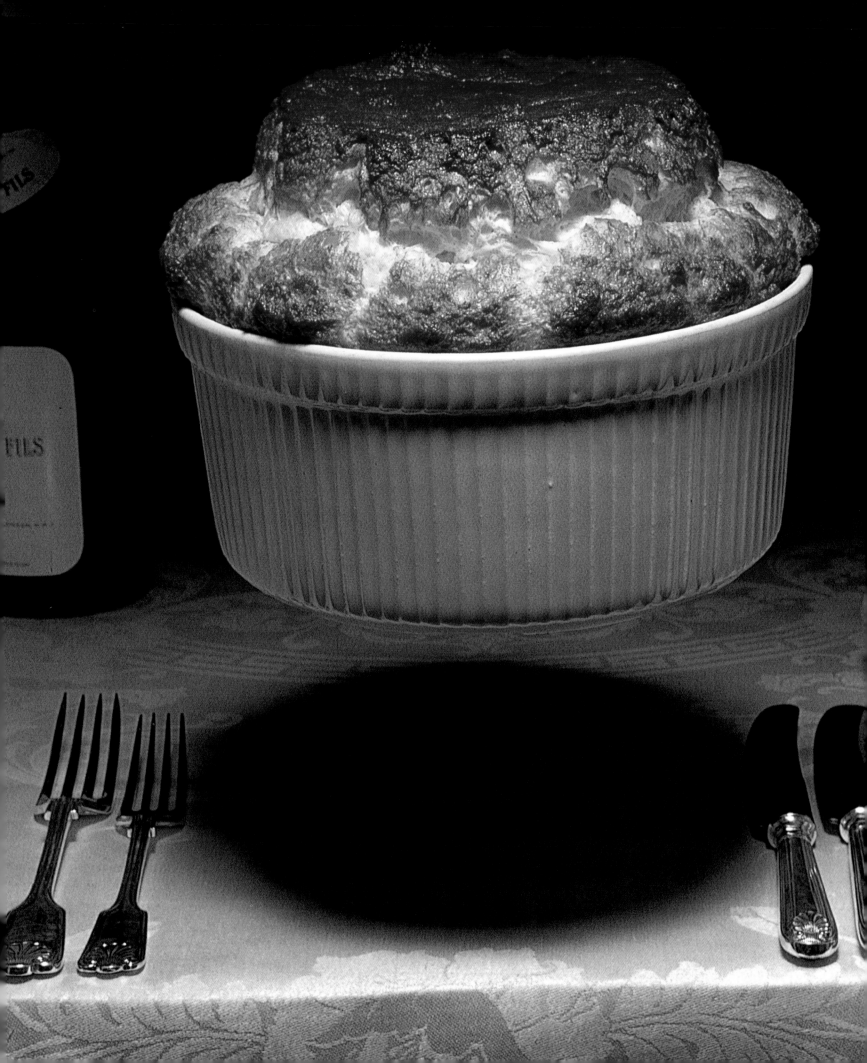

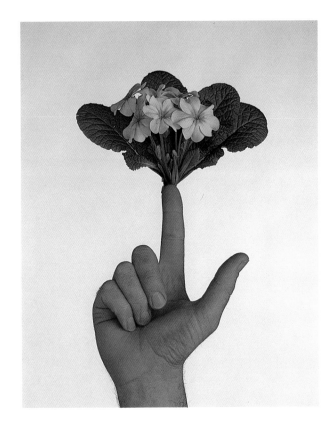

1972-1982
The cover for the Spring gardening feature in the *Radio Times* (see also page 62/63). The finger belongs to the photographer and the primula is stuck to it by glue. Terry Potts was responsible for the retouching.
1978. Hasselblad 150mm
Kodak Ektachrome

If 'Making a soufflé is child's play' (a Prue Leith feature in *Nova*), photographing it is anything but. Caroline Evans, Tony's wife and assistant, made soufflé after soufflé in the kitchen, which was downstairs from the studio. By the time they arrived in front of the lens they were rejected as either too light, or too dark but mainly as too low. In the end they called in the gas man and moved the cooker up into the studio. What you see is Caroline's nineteenth nervous soufflé.
1973. Nikon 55mm
Kodachrome

Previous pages.
For a *Nova* feature on rabbits in November 1973 (see also page 86).
1973. Hasselblad 150mm
Kodak Ektachrome

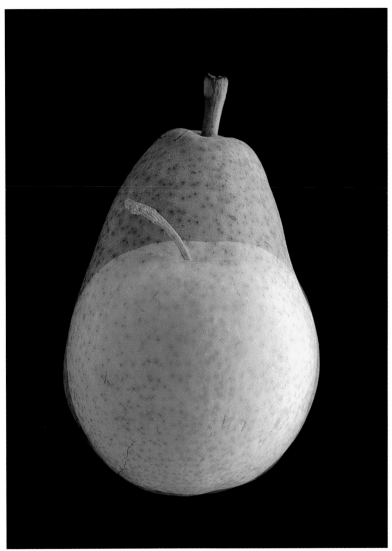

Double-exposed apple and pear for an autumn cookery feature commissioned by Robert Priest, art director of *Flair* magazine.
1972. Hasselblad 150mm
Kodak Ektachrome

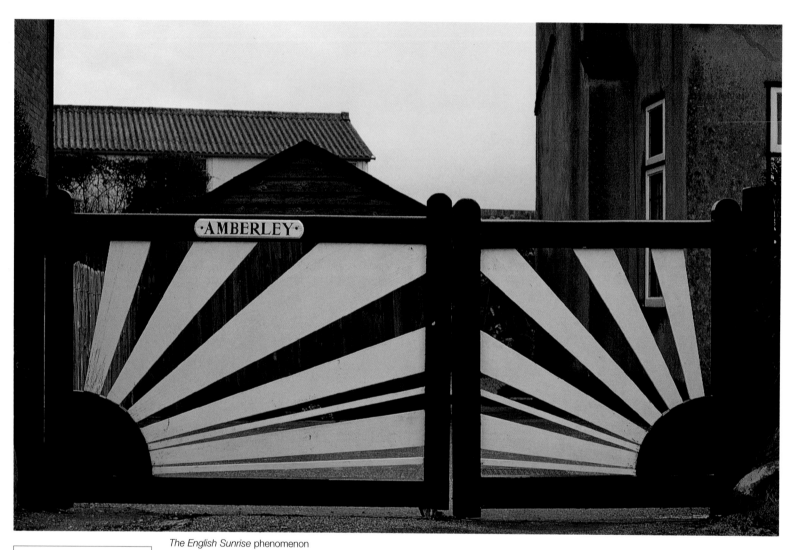

The English Sunrise phenomenon began when Evans was asked to photograph actual sunrises for a lecture on the 'unconscious use of design' by his long-time friend Brian Rice. As he wrote: 'I began to notice how widespread it was as an image and the book grew out of that.' Evans and Rice worked on the book on-and-off for two years. *The English Sunrise* was published in 1972 by Mathews Miller Dunbar with book design by David Hillman. Now a collector's item, it broke new ground with its one image per page and no words.
1970-1971. Mostly Asahi Pentax on Kodachrome and Ektachrome

The English Sunrise
1970 -1971.

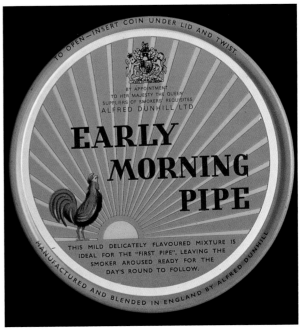

The English Sunrise
1970 -1971.

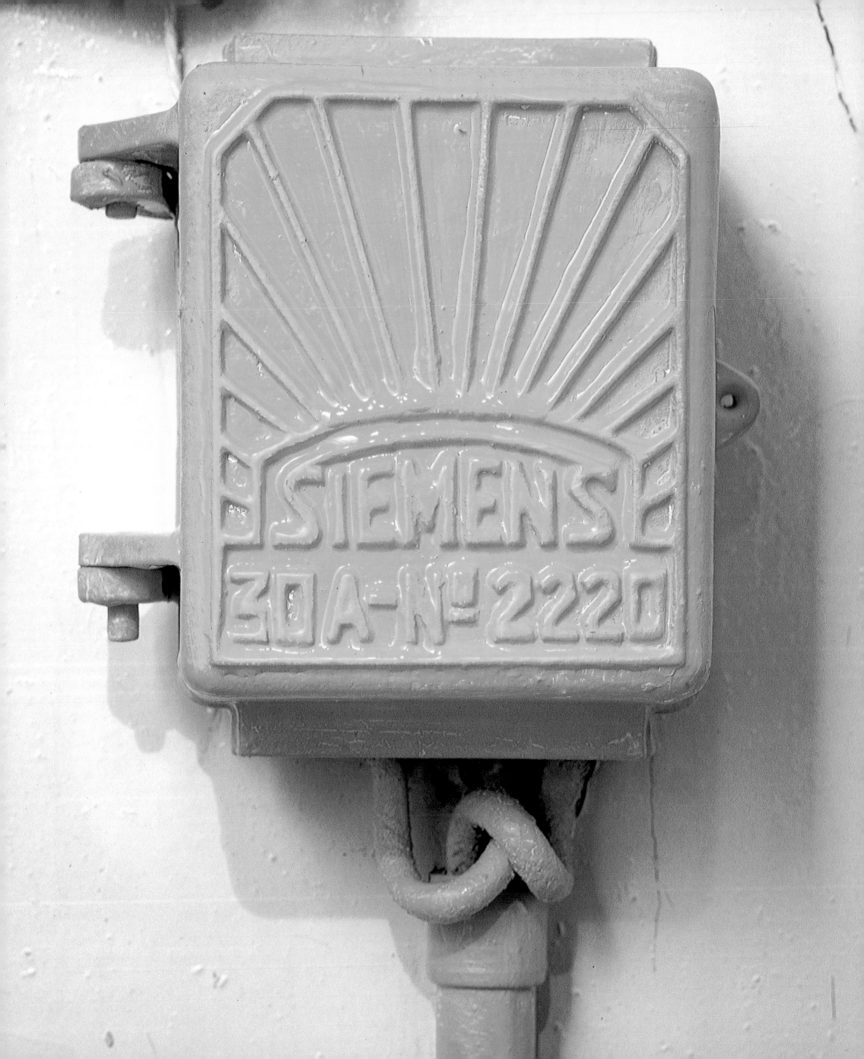

The English Sunrise
1970-1971.

The English Sunrise
1970-1971.

The English Sunrise
1970-1971.

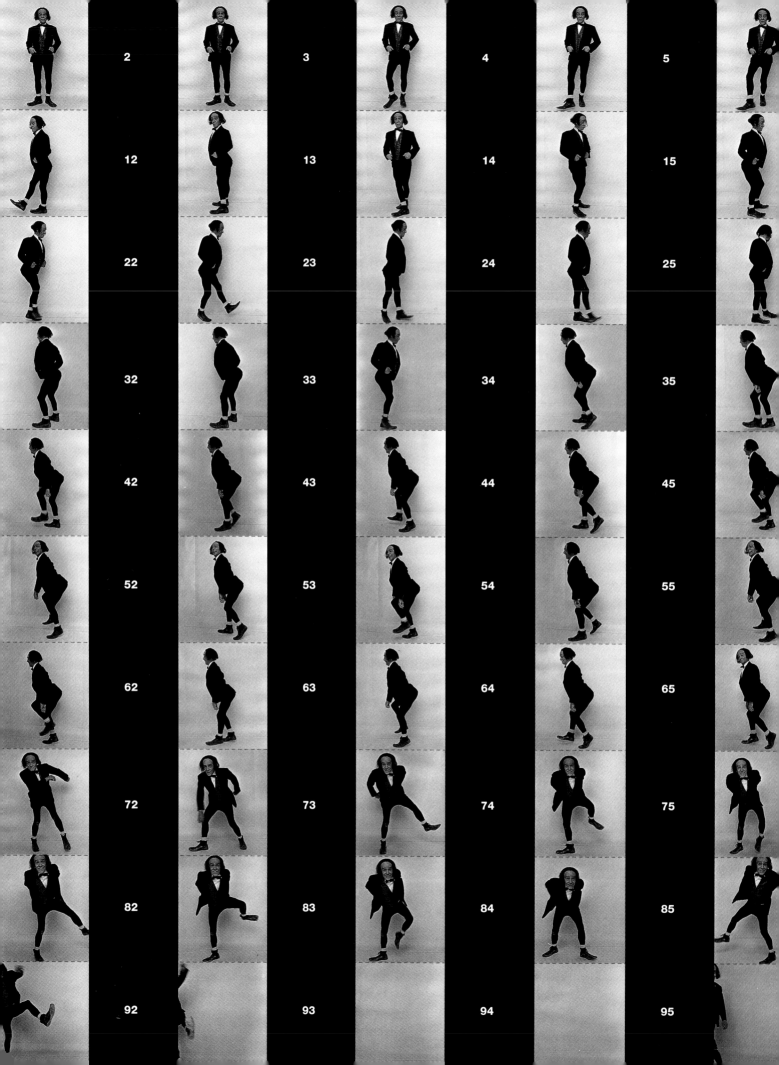

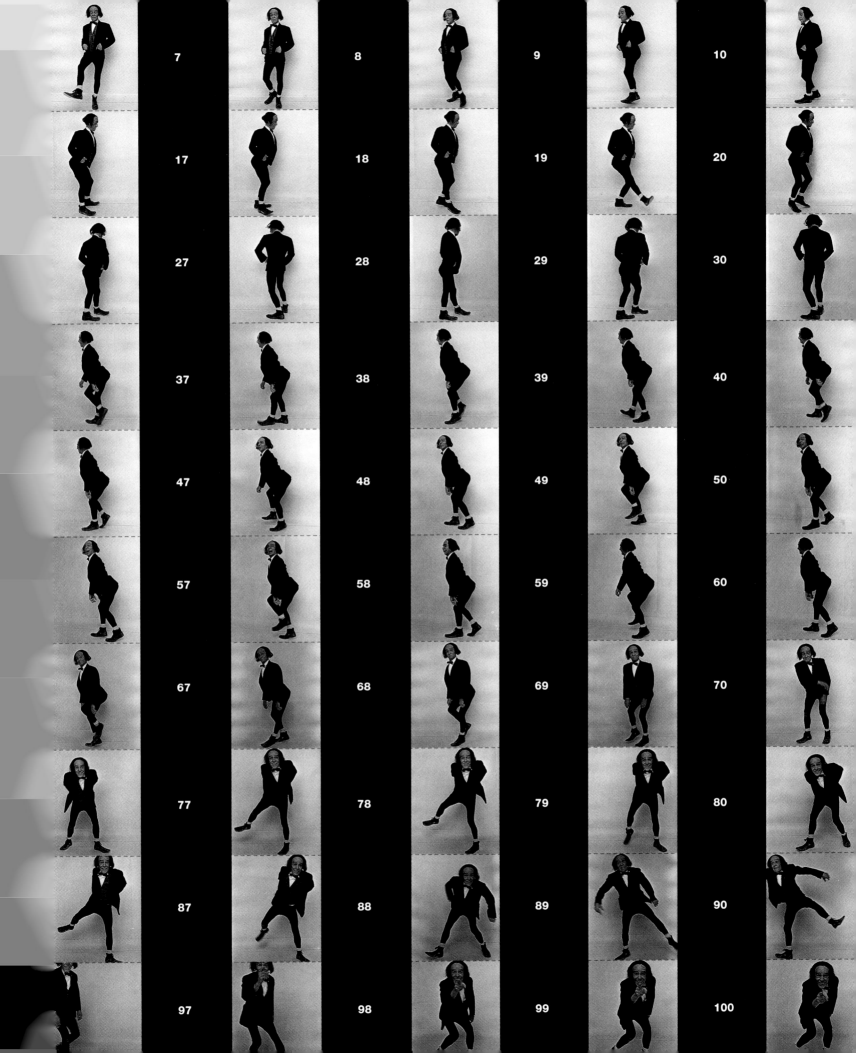

Right.
A three-year-old lady gorilla called Bamenda, the cover photograph for a *Toronto Star Weekend* magazine article on Gerald Durrell's zoo on Jersey in the Channel Islands. Art director was Robert Priest.
1979. Nikon 55mm
Kodachrome

The Max Wall portrait was taken for the same profile in *Nova* as the series on the previous page.
1974. Hasselblad 150mm
Ilford FP4

Previous pages.
This series of Max Wall was commissioned by David Hillman at *Nova* for a profile by Russell Miller. The series could be turned by the magazine reader into a flick book that would animate the famous duck walk of the comic's 'Professor Wallofski' character.
1974. Nikon 35mm
Kodak Tri-X Pan

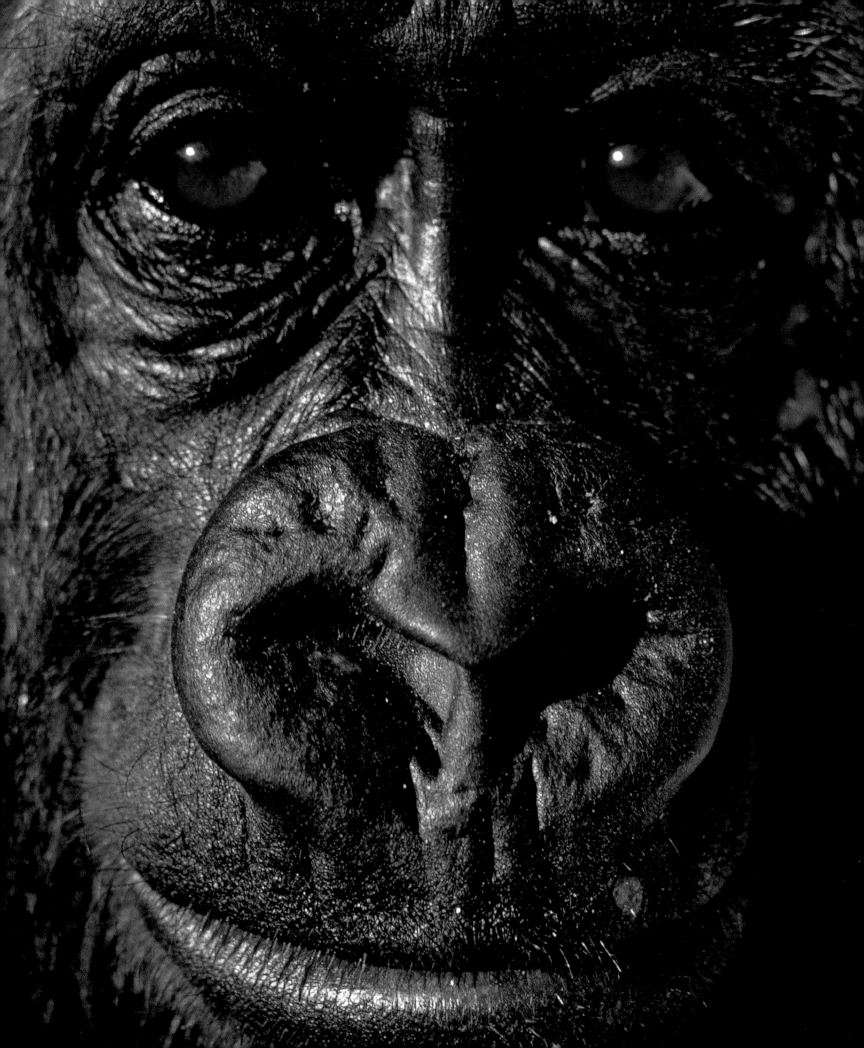

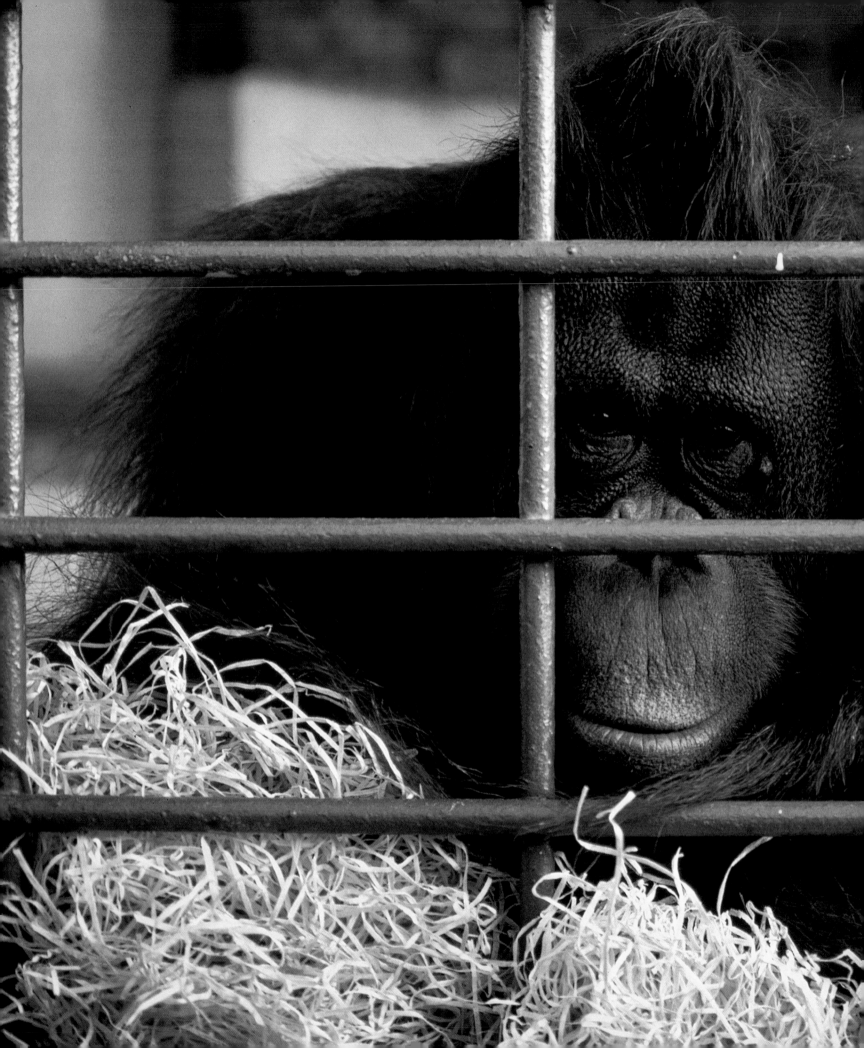

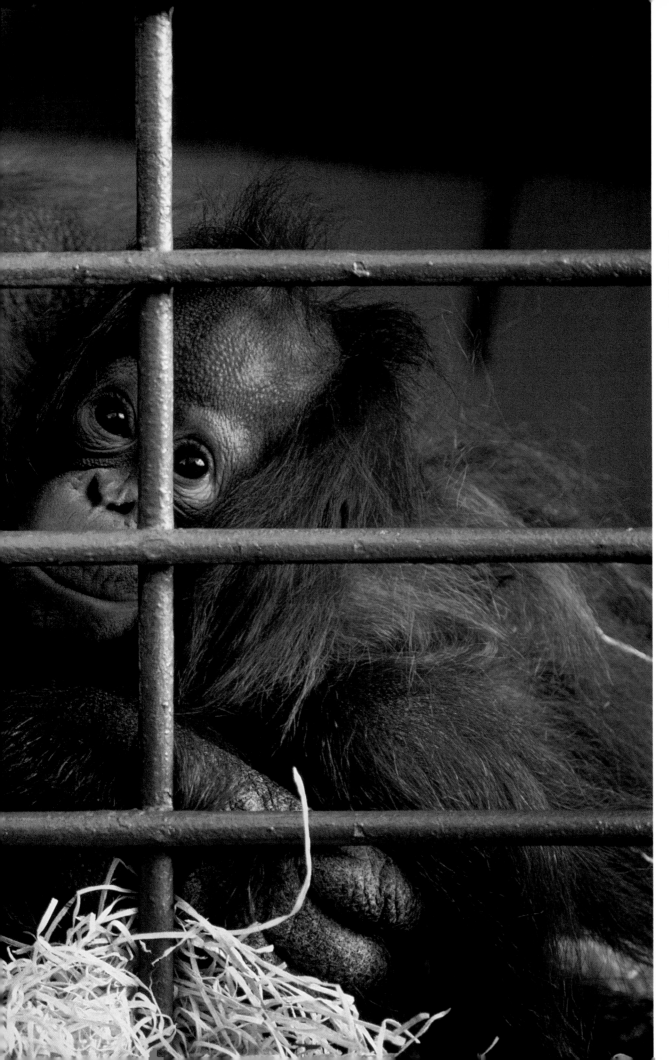

Orang-utangs – the inside spread for the same *Toronto Star Weekend* magazine article as the gorilla on the previous page.
1979. Nikon 55mm
Kodachrome

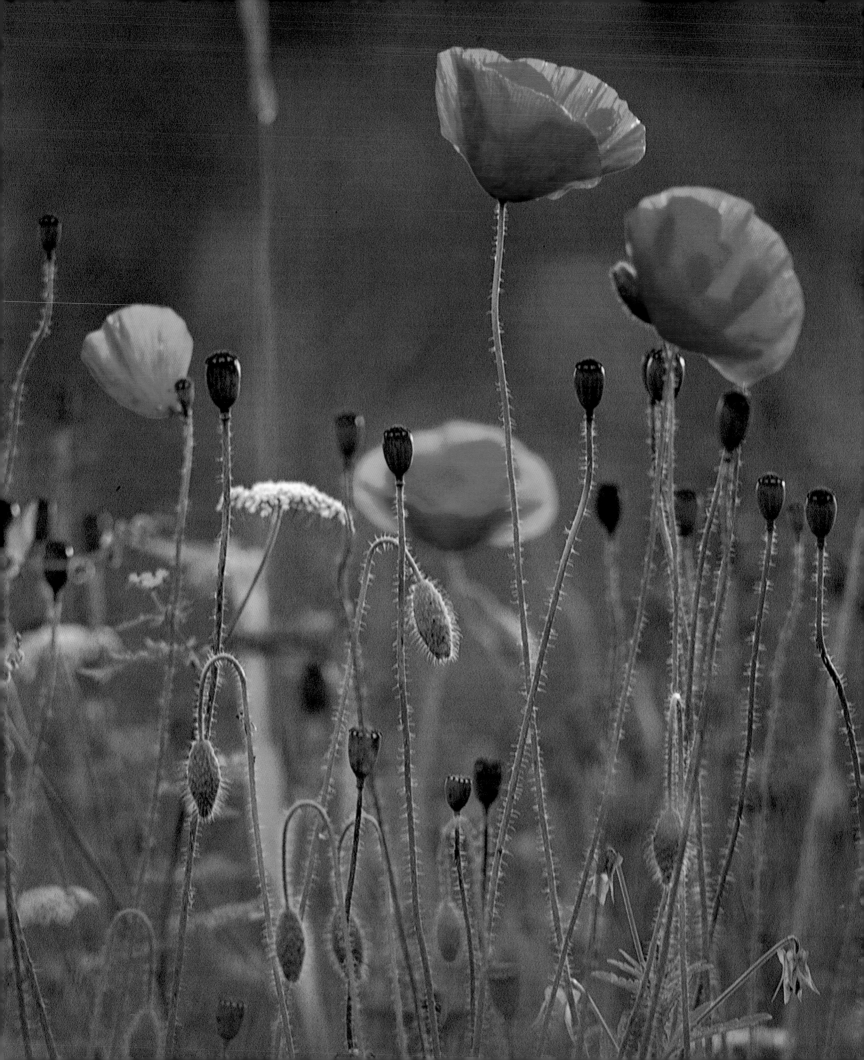

Richard Mabey is a writer specialising in the countryside and natural history. His recent books include *The Book of Nightingales* and *Flora Britannica*. He was a freelance when he started collaborating with Tony Evans on *The Flowering of Britain* in 1972.

'At times like this Tony became a plant.'

Richard Mabey

It's odd, but the sharpest memory of the six summers that I spent on the road with Tony while we were working on *The Flowering Of Britain,* is not of some exquisite bloom or spectacularly ornamented landscape, but of lunch. Tony, as always, believed that anything worth doing was worth doing magnificently, and our mid-day field snacks always turned into elaborate hedonistic picnics. Like characters from the Manet painting, we would spread a tablecloth on the grass and sprawl next to it. Then we talked, seminars of talk, about the morning's work and afternoon plans, about background and narrative, about life and withering and regeneration – and how focusing could express these cycles.

We had met on a commission from *Nova,* and seemed so much of one mind that I rapidly recruited Tony to collaborate on a book I had long been planning on the social and cultural history of our flora. I guessed he would rapidly absorb the idea of plants as indicators of history, but had no inkling of just how much I would be changed by his visual wisdom. One of our first joint trips was to Bradfield Woods in Suffolk, to try for oxlips. I learned then about Tony's patience and meticulousness, his insistence on truly *seeing* a subject before even unpacking the

Corn poppies (*papaver rhoeas*) for the book *The Flowering of Britain*. Tony Evans collaborated very closely with the author Richard Mabey for six years during the 1970s on this project. The book contains 45 photographs and was published in 1980 by Hutchinson.
1973 - 1979. Mainly Nikon on Kodachrome

camera. He knew next to nothing about botany then, but proved to have an instinctive ecological eye. His finished picture of the oxlips gave a glimpse of the style that was to transform the art of plant photography. An oxlip clump rises like a sheaf in the foreground. It is tangled up with dead twigs, young leaves and flaying grass stalks. Behind it, caught by the wide-angle lens, the ancient coppice shears away towards the sky. It is a picture of a plant not just with an ecological history, but its own unique character, and its own present relations with the light, the weather, its neighbours and this special moment in the wood.

In the years up until 1978 we spent the spring and summers exploring places like this. We stalked Scottish alpines, despairingly, with an altimeter, then found them at sea-level by a loch. We walked the quaking hummocks of the New Forest with a tripod adapted for bogs by the addition of ski-stick ends. We had customised weather forecasts for Cambridgeshire parks. And we reached Mark 10 in a series of wind-tents made for photographing shaky plants on high hills. Tony found gadgets irresistible, but they always brought the plants closer, never distanced them.

Our expeditions weren't always successful, but then that was part of Tony's honest approach to nature, too. In 1974 we were in the Derbyshire Dales. It was a baking day and climbing towards Lathkill Dale Tony suddenly

stopped, pulled the scissors from his immense rucksack of equipment and said 'Cut my legs off, Rich.' Later we found a colony of columbines, both blue and white, and Tony, now wearing nothing but his newly be-shortened jeans, set to work under the fierce sun. He stayed in the same spot for the next six hours, and I watched him with growing anxiety, as he rotated round the columbines like a sundial's shadow (or maybe like a heliotrope: I always felt that at times like this Tony *became* a plant). But the picture didn't work. The columbines looked gangly and parched, sticking out of the short grass on the hill. I understand why now, since they are really woodland plants, and as Tony always insisted, you cannot photograph what is not there.

But we had our best times amongst limestone plants and landscapes. They had a frankness and vivacity that suited us. In the Burren, especially, Tony took some of his most evocative pictures. In one, a group of burnet roses surround a flat white rock. In the rock is a puddle, like a tiny turlough, and on its dead calm surface a reflection of the sun is encircled by fallen cream rose petals. It is a vision of the Burren in miniature.

Many years later I think I found the exact spot where Tony took this picture. It was as hauntingly beautiful as I remembered, but, needless to say, totally different from the original photograph – which remains a triumphant record of a unique and unrepeatable moment.

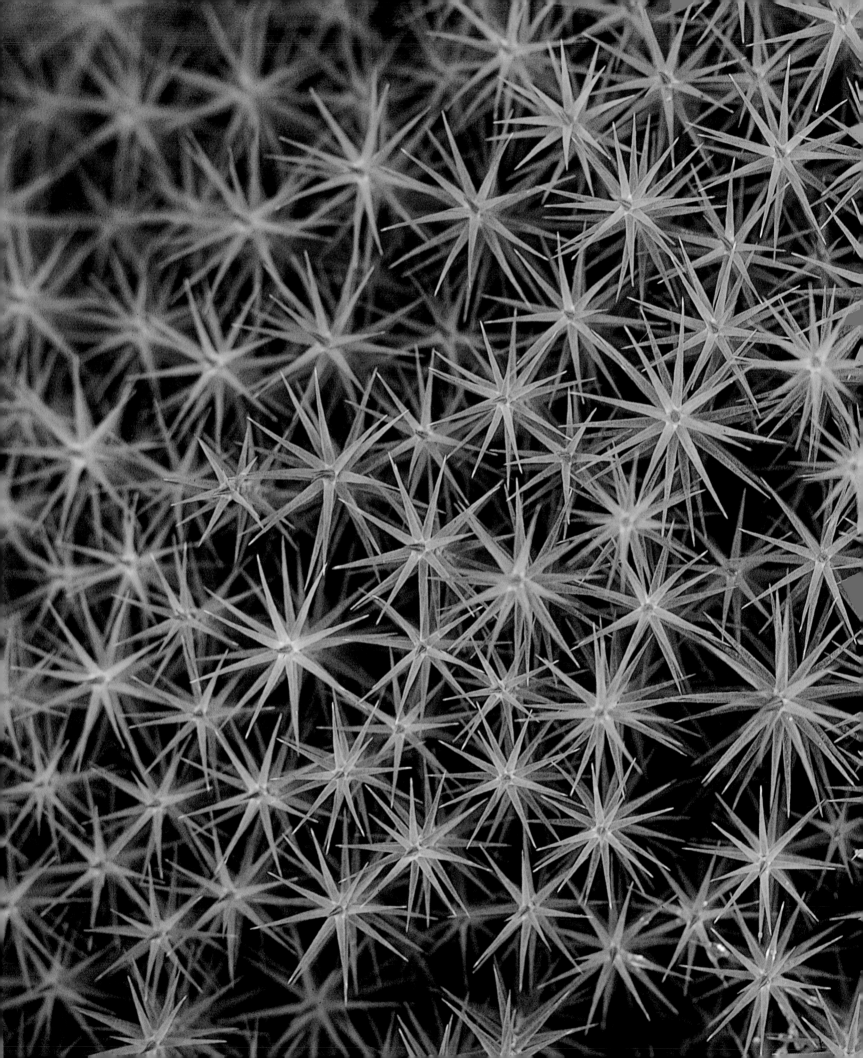

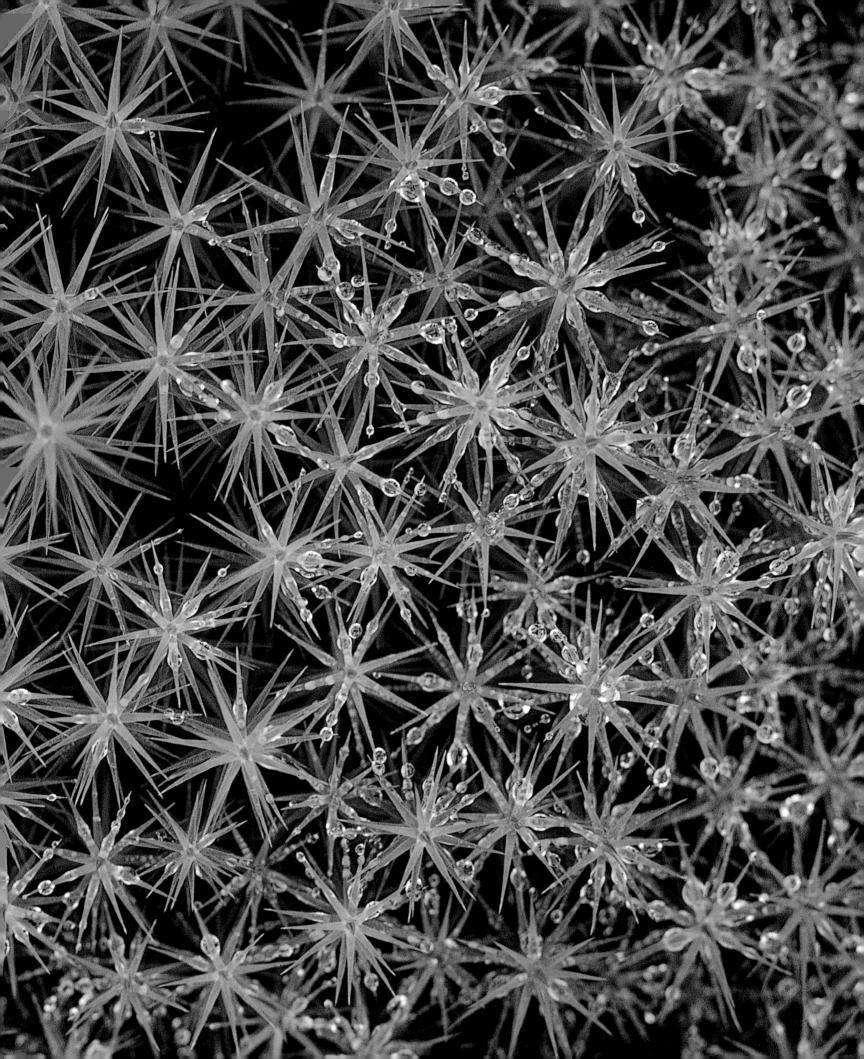

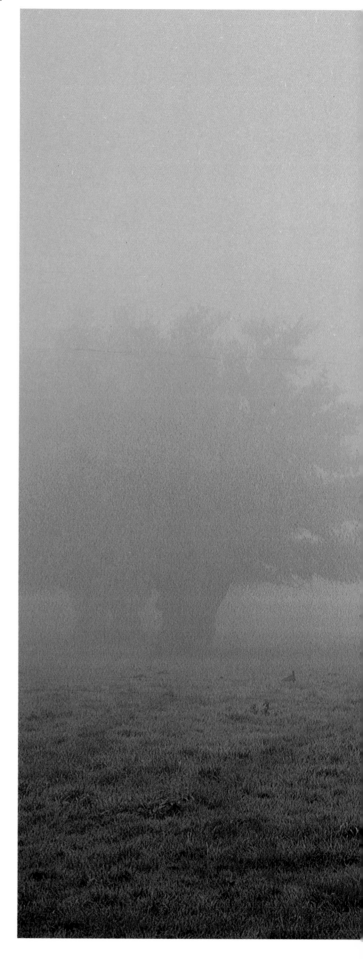

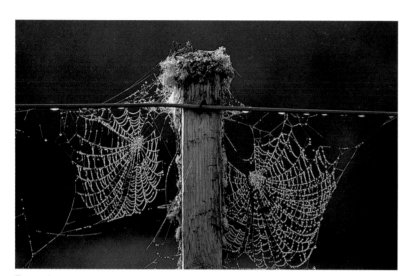

Evans photographed the dewy
cobweb one early morning while
in Inverness-shire. It was later
published in the *New Scientist*
in 1977.
1973. Nikon 35mm
Kodachrome

Previous Pages.
Evans took this photograph of
the moss *polytrichum commune*
for himself. It was later used in
Patterns in Nature, published
by Penguin Books in 1975.
1973. Nikon
Kodachrome

Early one morning in October
1977, Evans was preparing to
photograph 'the ancient pollard
boundary elms in the deserted
medieval village of Knapwell,
Cambridgeshire' for *The
Flowering of Britain*. As the mist
began to clear a white horse
materialised, as if by magic.
Had he hesitated the picture
would have been ruined – a row
of monstrous electricity pylons
also appeared out of the mist
minutes later.
1977. Nikon
Kodachrome

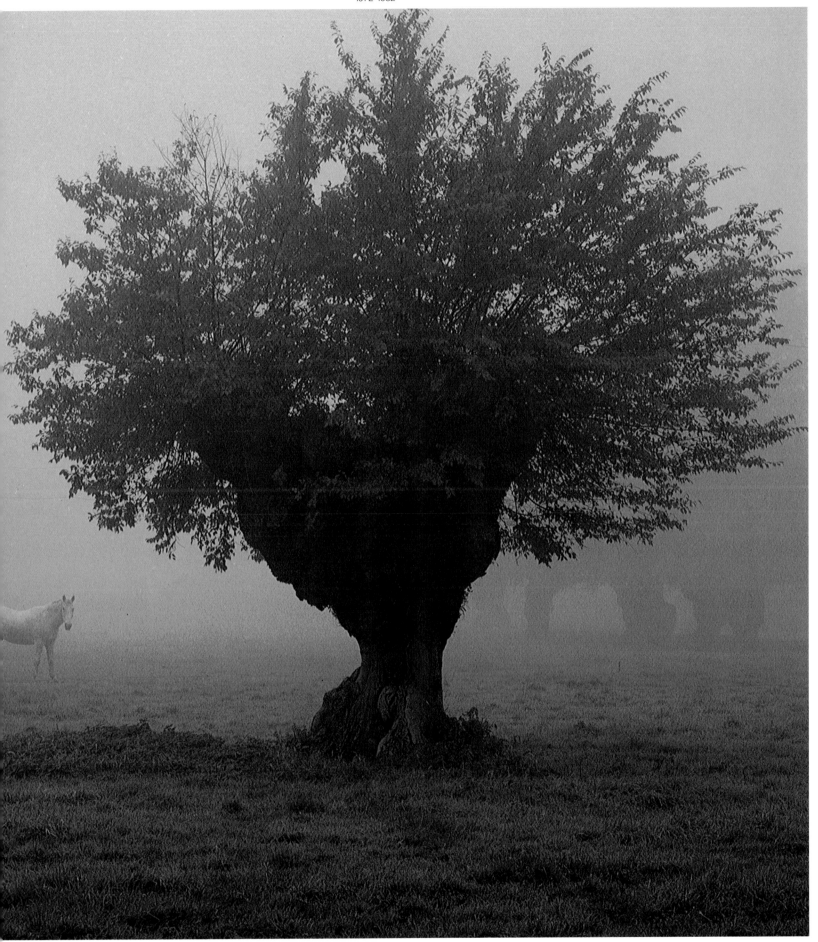

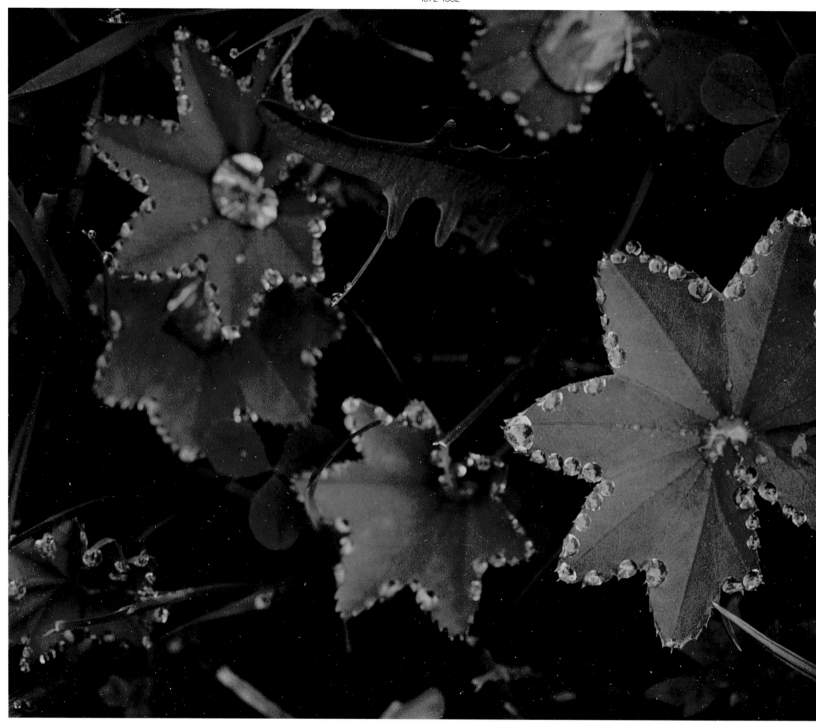

This is the first time this picture of Lady's Mantle (*alchemilla vulgaris*), taken in Scotland, has been published.
1976. Nikon
Kodachrome

A leaf speared on grass, another photograph originally taken for himself. It was used for the cover of *Woodbrook*, a novel by David Nairn published by Penguin Books in 1976, for a promotional poster for the Bee Gees in 1978, a Nature Conservancy Council poster in 1979 and in 1982 for *Evergreens*, one of the Music Sales sheet music compilation series designed by John Gorham.
1975. Nikon 70-120mm Vivitar
Kodachrome

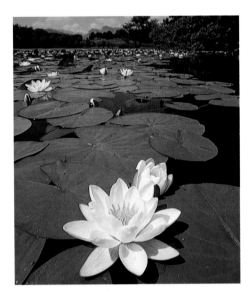

Originally shot for *The Flowering of Britain,* this photograph of the water lily *nymphaea alba* went on to adorn a *Sunday Times Magazine* cover and a *Radio Times* cover. Evans wrote this about it: 'It is much easier to shoot flowers with a narrow depth of field because you can work with a much faster shutter speed. The result, too often, is that a large proportion of flower pictures look as if they have been taken with a flash gun. To get depth of field you need a smaller aperture and slower shutter speed and that is where patience comes in. To get this picture I stood in a pond for almost an entire day, waiting for one calm three-second period when everything stopped wobbling. I spent ages at the beginning waiting for a dragon-fly to settle on the water lily as well, but in the end I had to give that up and I was quite happy to go with this picture.'
1975. Nikon
Kodachrome

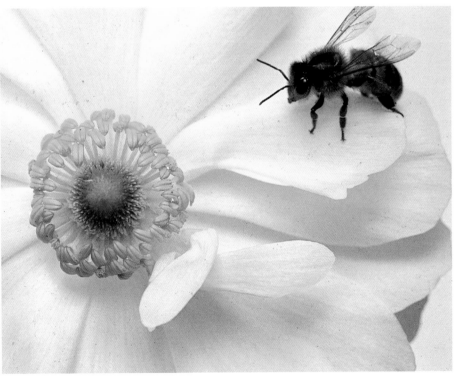

First used for the Readers' Digest *Amazing World of Nature* in 1969, the bee and flower (*ranunculus*) were also published by Octopus in *The First Nature Book* in 1976, then in the *Radio Times* in 1978 and by Penguin Books in 1980.
1969. Asahi Pentax
Kodak Ektachrome

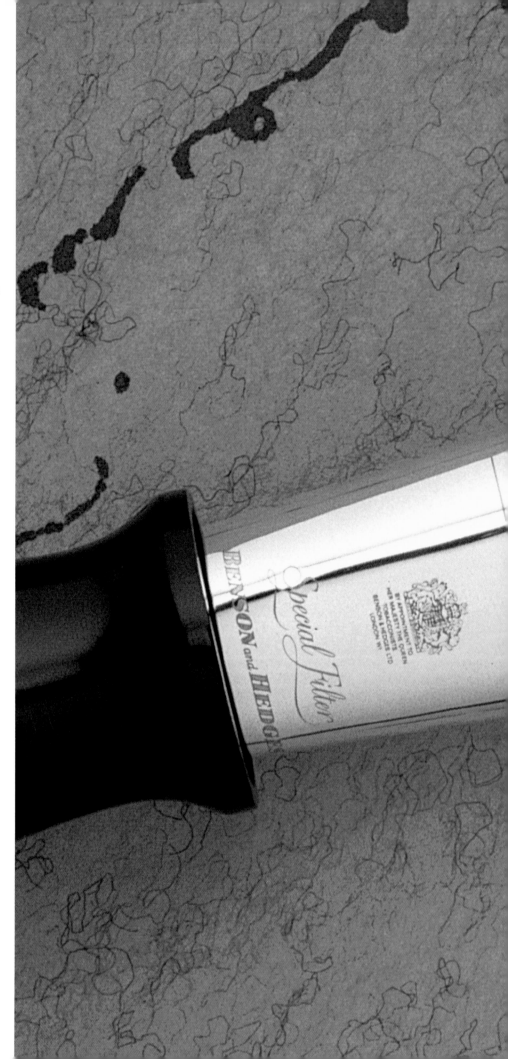

The pen was 3 ft long and created by model-maker Guy Hodgkinson for this Benson and Hedges poster and press advertisement. The size, including the giant piece of blotting-paper background, allowed for the incredibly fine detail. The picture won a D&AD Silver Award in 1980. The art director was Graham Watson and the agency Collett Dickenson Pearce.
1978. Nikon 35mm Kodachrome

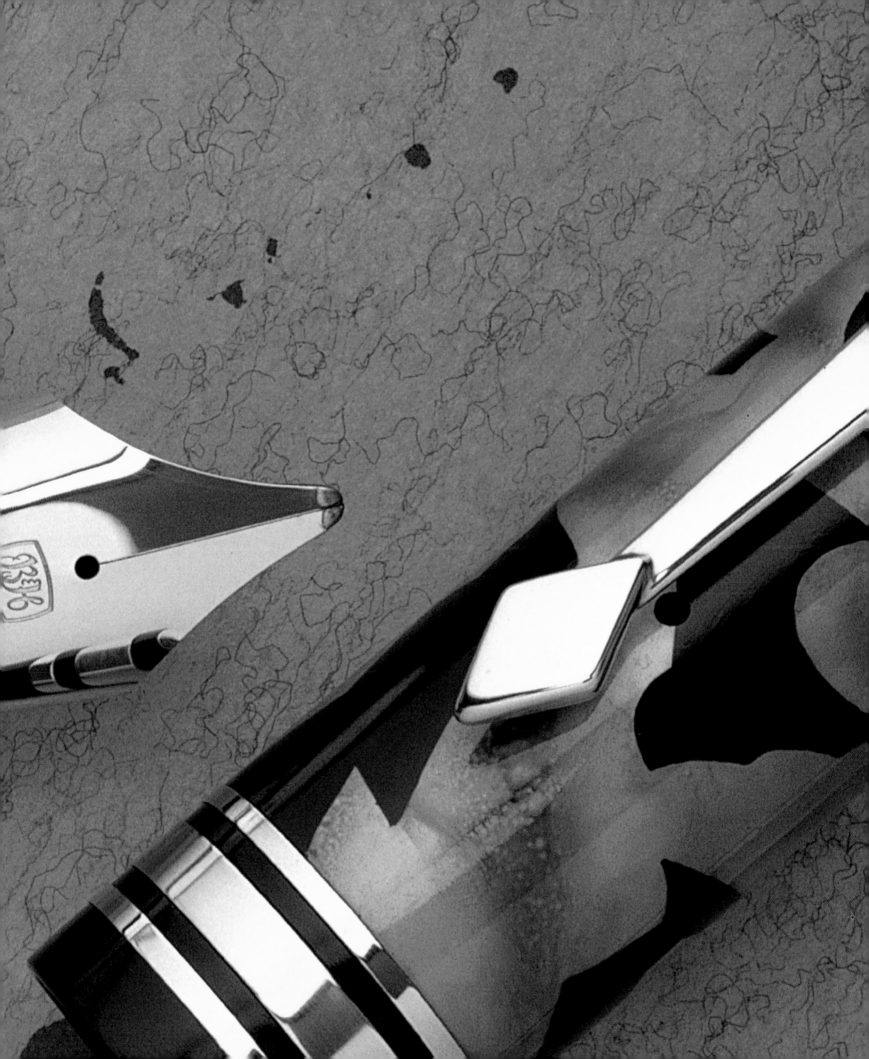

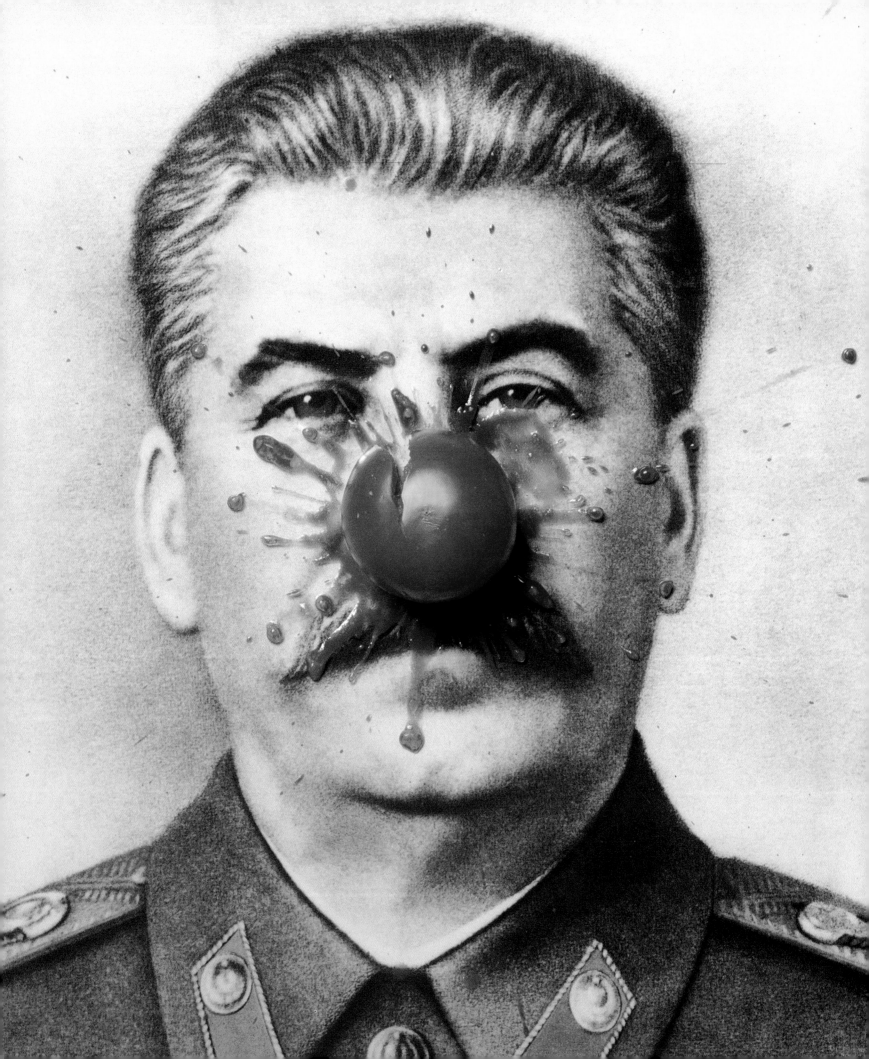

1983-1992

Working with Richard Mabey on The Flowering of Britain *through the 1970s had given Tony Evans an inkling of the direction his life and work should go. He became keen to be less embroiled in the hurly-burly of metropolitan media life and this ambition he began to realise in 1983 when he and his family moved from London to a Georgian pile among 32 acres on a hill in mid-Wales. Here he could concentrate more on the countryside and wildlife, which had become his passion. As well as continuing editorial, corporate and advertising work, his commissions during this time included the commemorative RSPCA stamps for the Post Office, one of the all-time best sellers.*

He became unwell in the summer of 1985 and after a spell in hospital he took advantage of the secluded life offered by his Montgomeryshire home and embarked on more of his own projects. He started the Designers' Own Company to revive the tradition of commemorative cards allied to Post Office special issue stamps. He also completed Iris Flowering, *an exquisite set of prints, which was issued in 1990. Tony Evans died in 1992.*

The Stalin poster for *Red Monarch,* produced by Enigma for David Puttnam's Goldcrest Films, was designed by John Gorham in collaboration with Howard Brown. The 'blood' was not splattered but very carefully applied to the found image of the old dictator.
1983. Hasselblad 150mm Kodak Ektachrome

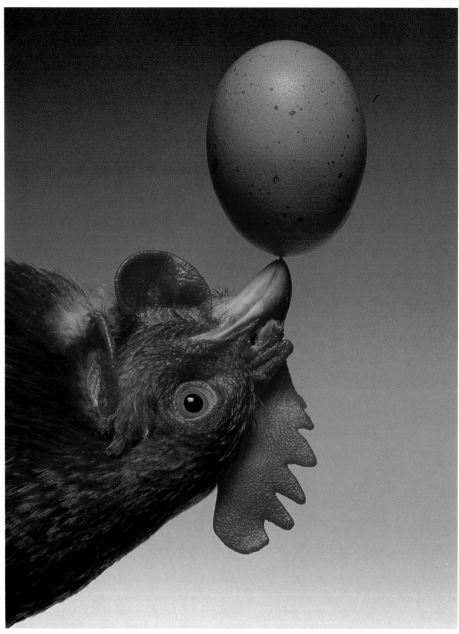

Taken in May 1986 for a British
Gas advertisement, this was
Evans's first job after returning
from six months of illness.
The point was that British Gas
has underground machines
called 'moles' that run around
inside their pipes checking for
problems. May is not a good
month to find moles and, after
spending a long time looking
around near his home in Wales
with the deadline getting closer
and closer, Evans was just
about to call the agency to tell
them he had failed when his
cat passed by the window
carrying a dead mole in its
mouth. It was rushed to the
taxidermist to be stuffed and
then set up for the photograph.
The agency was Young and
Rubicam and the art director
Michael Durban.
1986. Hasselblad
Fujichrome

The egg was blown first to
make it light and then stuck to
the hen's beak, and Evans was
apoplectic when the *Sunday
Express Magazine* printed the
photograph upside down.
Marie France used the picture
the right way up for the cookery
series 'Au Fond du Jardin', art
director 'Yan D Pennor's.
1982. Hasselblad 150mm
Kodak Ektachrome

Following pages.
A nursing recruitment
advertisement for the Central
Office of Information which
reputedly had people dropping
their magazines in fright when
they came to this spread. It
won a D&AD Silver Award
in 1984. The agency was
TBWA and the art director
was Malcolm Gaskin.
1982. Hasselblad 150mm
Kodak Ektachrome

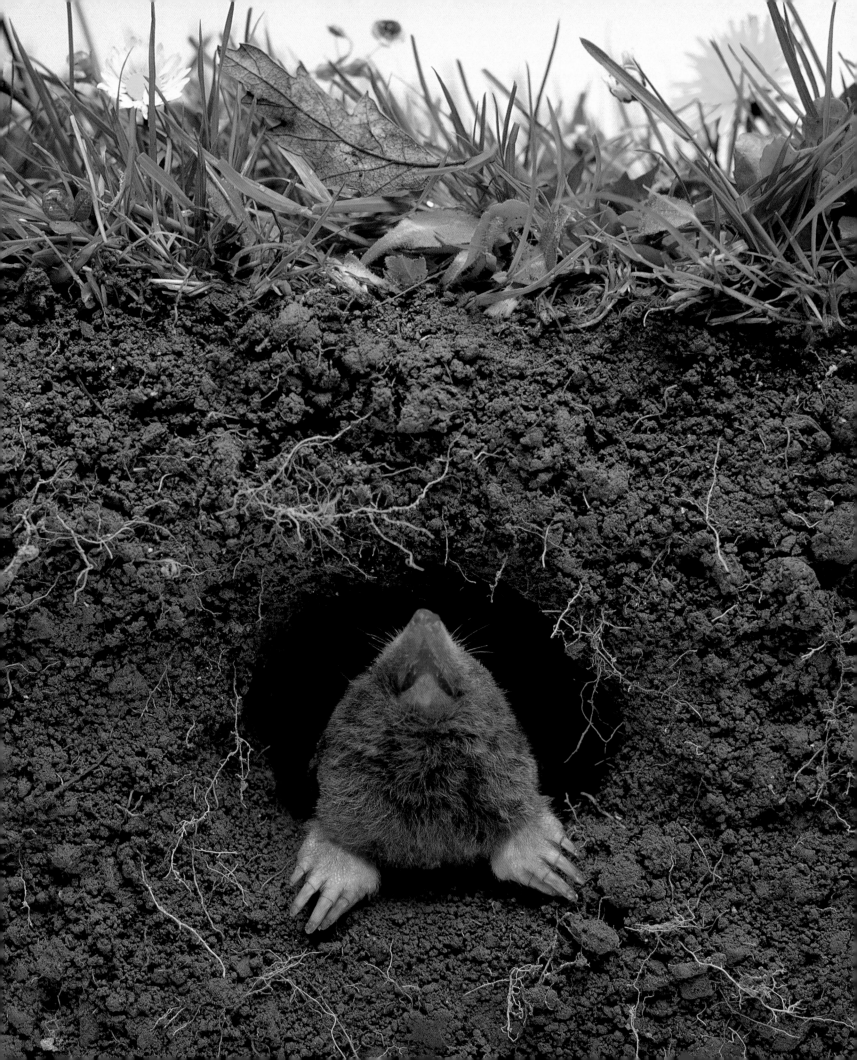

A spider down the back of the neck is enough to give anyone the squeeby-jeebies.

But finding pictures of them crawling over the page of a magazine is hardly likely to send shivers down your spine or have you running for your life.

This would be ridiculous. Or so you might think.

But for some people, just the thought of spiders can fill them with fears on a scale you'd find hard to believe.

In their mildest form, these feelings amount to little more than a clammy uneasiness.

Like the sense of panic you may have experienced as a child closing the door on yourself in a cupboard.

On a more serious level, they can develop into an acute anxiety attack. In a blind panic you have only one thing on your mind. To escape.

In this state, the fear of finding a spider in the bath, or in the kitchen sink, can turn everyday events like washing or doing housework into terrifying ordeals.

When people develop fears quite out of proportion to the threat of the thing they are afraid of, this fear is called a *phobia*.

There are many different types of phobia. One of the commonest is *agoraphobia* (the fear of open spaces), when you're literally terrified of venturing outside your own front door.

Other relatively common phobias appear, on the surface at least, to be rather absurd. Like the fear of wearing shoes, getting dirty, stroking cats or having a bird fly near you.

People with serious phobias openly acknowledge that their feelings are irrational. But when faced with them, they cannot control their fear.

When things get to a point when their

Could you talk running away

phobia prevents them from carrying on life as normal, they seek help.

There are several ways of helping someone get over his fears. One method is called *graded exposure.*

The idea of graded exposure is to confront him with his phobia, bit by bit, one stage at a time.

This is done by working out a hierarchy like the one below, and taking him carefully from what he finds least scary, to what he finds most terrifying – the situation in real life he wants to overcome.

1. Toy spider.
2. Film with spider in background.
3. Film of spider close-up.
4. Seeing spider in jar several feet away.
5. Seeing spider on table several feet away.
6. Seeing spider crawl on nurse's hand several feet away.
7. Standing next to nurse holding spider in hand.
8. Touching the spider whilst in the nurse's hand.
9. Briefly holding the spider whilst nurse is present.
10. Returning spider to its jar.
11. Standing beside nurse, who removes spider from jar and lets it crawl over hand, then returns to jar.
12. Removing spider from jar himself, letting it crawl over own hand, returning it to jar.

If you think you might find this kind of work more fascinating than getting sucked into some dreary office routine, you may be curious to know more about nursing the mentally ill.

Clearly, assessing someone with a serious phobia, working out the correct programme and putting it into action is not easy as it sounds. It takes immense skill.

someone out of from this page?

And team work. As a Registered Mental Nurse (RMN) you don't work alone. You're part of a team of other highly trained professionals, including psychiatrists, clinical psychologists and social workers.

Which is just a well, for making someone face up to the apparent ruins of his life is no less demanding than helping someone overcome an irrational fear of spiders.

Or simply caring for him on a day-to-day basis.

And because each person's problem is different, you can't always fall back on set methods to help you. Your ingenuity and imagination are working overtime from the minute you come on duty.

Perhaps this is the kind of challenge you're looking for, but do you think you could be suffering from a mild sort of 'phobia' yourself? A fear of working in a 'mental hospital'.

As an RMN you quickly learn how a normal mind can become ill just as a normal body can.

And that psychiatric hospitals, like general hospitals, are there not to keep people in, but to help to get them back to a normal way of life.

Few people know that over half the patients admitted to psychiatric hospitals are home again within a month.

Or that nine out of ten of them leave within a year.

Or that some psychiatric nurses only work in hospitals on very rare occasions. (Sheltering someone from the outside world may not be the best way to get him to cope with it.)

But having said this, nursing the mentally ill is not for everyone. To begin with, the training takes three years. With hospital and community experience, practical assessments and tough written exams.

But the way we see it, if you can overcome your own fears, you may well have what it takes to help others overcome their's.

You could do both by writing to the Chief Nursing Officer, P.O. Box 702, (MI/19), London SW20 8SZ, for more information.

Nursing

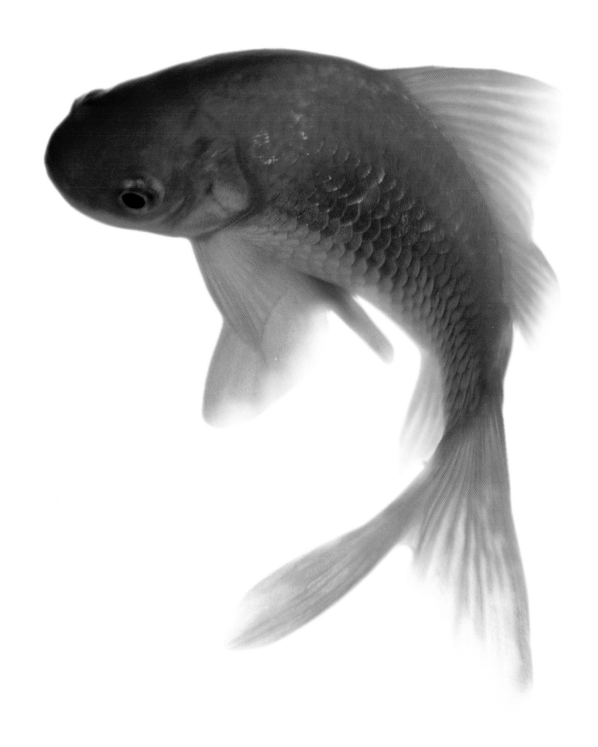

Michael Wolff was co-founder of Wolff Olins and its creative director from 1964 to 1983 when he left to develop his own design consultancy. In 1987 he became Chairman of Addison in the UK and worldwide creative director.

'Tony had an eye like a zoom lens.'

Michael Wolff

Tony Evans was a master craftsman. He was inspired by the colour and humour of life. He was a designer – even more obsessive about the look of everything than I am. And especially obsessive about how things worked.

Sometimes, when I was tired and ready to risk a short cut, I was irritated by his meticulousness. Just at the moment that I was tempted to settle for less, Tony would know how to keep me focused, as he always was, on getting the best. Even if it meant spending four hours in the freezing cold finding the perfect lemon in Covent Garden market at 5 am.

If he could, Tony would have modified everything in his life to make it just that little bit better. Better in every detail. He always knew what wasn't quite right. It was maddening. Tony opened my eyes to the elegence of the best in advertising. He loved it. And even though many art directors drove him crazy with what he called their muddy thinking and sloppy detail, he nearly always managed to win them over to a better, more elegant and witty way of doing things.

I worked with Tony on my company's goldfish symbol. It was a scary project. We found the fish together in an aquarium in Battersea. A beautiful and lustrous six-inch

The image of a goldfish was originally intended for the personal letterhead of design consultant Michael Wolff, but was adopted as the logo for the design firm Addison when he became a director there. The fish was photographed in a super-purity glass tank of absolutely clear water. 1985. Hasselblad Fujichrome

specimen. And then a saga started. Tony decided that the fish needed to be in a special super-purity glass tank. Four weeks production. Hundreds of pounds. Then it needed a special filter to keep the water as clear as the super glass. Another four weeks. Hundreds more pounds.

Then the goldfish wasn't well. Its colour dimmed. Tony thought it might be dying. We had to wait again. The fish recovered and finally I saw some pictures. We were both disappointed. The goldfish looked flat and ordinary. We were bitterly diappointed. I thought the whole idea of a goldfish was wrong and was ready to abandon it.

Tony went back to Wales to do more work. He produced an astonishing picture. We made the plates and printed it. It was stunning. I believe it had some magical powers. Its slippery form, in brilliant orange, seemed to swim through the paper on which it was printed.

When I used the goldfish as my symbol, wherever I went in the world, people frequently asked me for copies of my letterheads and cards. The goldfish attracted more attention than almost any job I've ever done. Eventually, when I joined Addison, it became the symbols for all the Addison Design Companies around the world. The goldfish had become a valuable international symbol.

Tony Evans had an extraordinary eye. It was like a zoom len. In a flash he could adjust his focus from a sunset to a cow's whisker. He could see everything.

Even the smile on a kitten's face. He shot the wonderful RSPCA stamps in my kitchen in London. All the animals, from ducks to dogs were auditioned there.

Tony was one of my closet friends. His craft was photography. But his genius was that of a discerning and inspirational designer.

Following pages.
The same team that produced the Benson and Hedges buried mosaic (see page 64/65) came together again for another poster and press advertisement image. The forge is in Suffolk near where model-maker Guy Hodgkinson lives. The art director was John Merriman and the agency Collett Dickenson Pearce.
1983. Nikon 20mm
Kodachrome

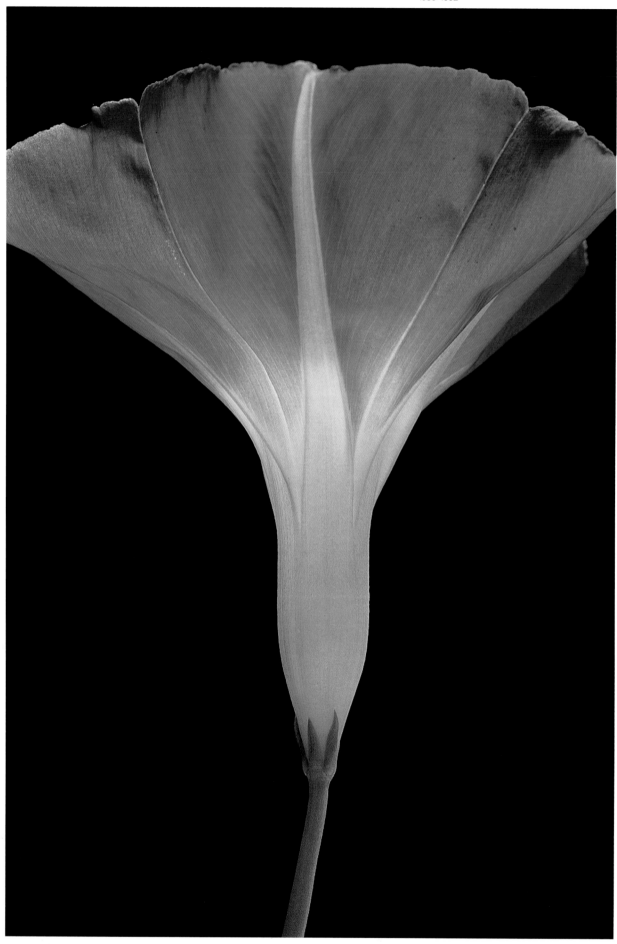

Convolvulus for Blue Circle's 1985
'Nature's architecture' calendar,
designed by Derek Forsyth.
1984. Nikon
Kodachrome

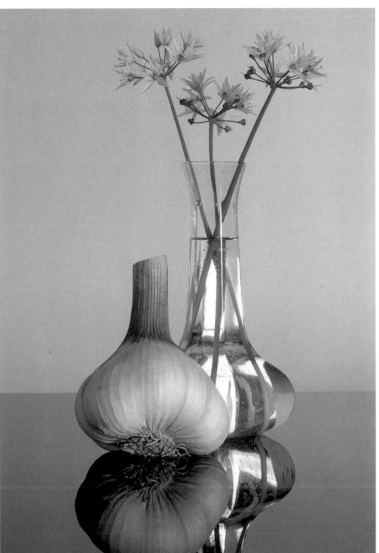

Garlic, one of a series of photographs taken for the 'Au Fond du Jardin' cookery series in *Marie France*, with art director 'Yan D Pennor's.
1983. Nikon 55mm
Kodachrome

The avocado was first used for the cover of the *Avocado Pip Growers' Guide,* published by Penguin Books in 1980 and later by *Marie France* in 1983.
1980. Nikon
Kodachrome

Tim Shackleton is copywriter, photographer and pseudo-nymous author of eight novels. He has worked extensively for the Royal Mail and met Tony Evans when they were both working on the Studio Pottery stamps.

'His sense of humour was wicked.'

Tim Shackleton

I think of Tony and I think of driving through the Ile de France. The Peugeot estate is full of his equipment, two of everything 'just in case', and I am scrunched up in the back seat in the company of two dozen bowler hats in assorted sizes. It may have seemed – as indeed it was – perfectly explicable to travel thus, but the customs men and the hotel staff wisely chose to feign indifference.

Of course, he didn't actually need the *chapeaux melons* in the end – the guy we had come to photograph chose, after a bit of a contretemps, to wear a fishing hat of his own. But Tony had to have them with him, 'just in case.' He had his own private agenda about things like that.

I liked his perfectionism. Every other perfectionist I have known – and I think I'm one myself – has been a total pain in the butt but with Tony it seemed not only necessary but welcome. I have admired his work since *The English Sunrise.* For some years afterward, I was in its thrall and remorselessly photographed dolphin motifs, bicycles and numbers, without a fraction of Tony's panache. The sheer weight of work involved, the amount of searching and the number of exposures necessary brought home the mark of the man.

Later, as a writer, I worked with Tony on a number

Evans was commissioned for a set of four RSPCA stamps to be issued in 1990. He photographed five young animals: a duckling, puppy, kitten, rabbit and lamb.
1989. Hasselblad
Fujichrome

135

of projects, notably the four sets of stamps he photographed for the Royal Mail. I liked his outward calm, the feeling of someone going through well-tried routines. Heaven knows what was actually going on in his mind but in the work, at least, one senses the concern for simplicity and orderliness, an almost monastic avoidance of the unnecessary. That reduction of images to their barest essentials has been massively influential in my own photography.

He respected people – that was one of the things I liked about him, as well as his ability to come up with the unexpected; he seemed to value new thoughts. He didn't suffer fools but it was nice to have one's opinions canvassed, to have him recall two-year-old conversations or even chance remarks. And it was always fun to have lunch or a drink with him. Ever the professional, he would reveal not one single half-secret of technique for my articles but there were off-the-record bonuses – the white mouse dangled in front of the kitten on one of the RSPCA stamps to attract its attention, the duckling made to stand still by humane use of Blu-tack, the strengthening bar discreetly removed from a historic stained-glass window 'in case it showed'. This might suggest a ruthless streak but he cared, he really cared about the subject as well as the photograph. You don't shoot things the way he shot them if you have a cold heart. His sense of humour was wicked.

Photographed for the 1990 RSPCA stamps, this two-day-old lamb from Bedfordshire was not used.
1989. Hasselblad
Fujichrome

Everything Tony did has a story attached to it. I wonder, in hindsight, if the stories occasionally took precedence over the images. Even in his own lifetime, they had become a form of currency in their own right.

John Gorham had designed a set of stamps for the Queen Mother's ninetieth birthday and he needed a picture of a rose for the presentation pack. He got Tony to do it. Now Tony always knew those little extra things and he decided it should be a Glamis rose, a great favourite of the old girl and named after her Scottish estate. At that time of year, the only place the Glamis rose was flowering was New Zealand. So Tony cheerfully ordered up a couple of cases or whatever measure one orders roses in (a great abundance anyway), so he could pick the very best one. John got wind that the cost of air freighting this lot half-way round the globe in a special refrigerated container would be about equal to his budget for the whole job. He nipped that one in the bud just in time and I think they used a ringer instead, something from Interflora. The picture only needed to be half the size of your little fingernail in any case, but Tony knew the difference. He always did.

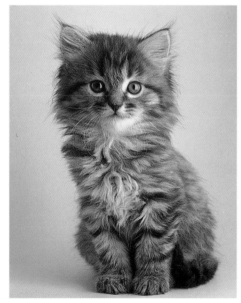

The kitten for the RSPCA stamps series. The set became the second largest seller of all time and won the Riccione Grand Prize for Philatelic Art, awarded in Italy by an international jury.
1989. Hasselblad
Fujichrome

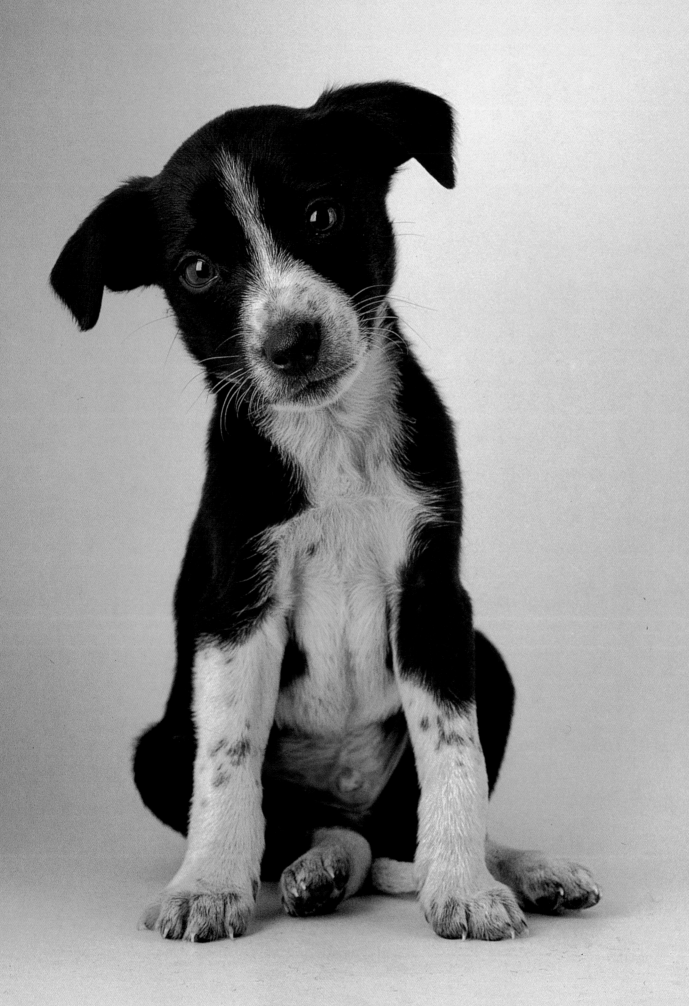

For the Post Office's set
of RSPCA stamps, the puppy
came from the Birmingham Dog's
Home and the duckling from
a battery breeder in Shropshire.
The duckling's feet had to be
temporarily stuck to the floor with
Blu-Tack because its legs had
the unsightly habit of splaying.
1989. Hasselblad
Fujichrome

Following pages.
RSPCA stamps reproduced
by kind permission of The
Post Office.

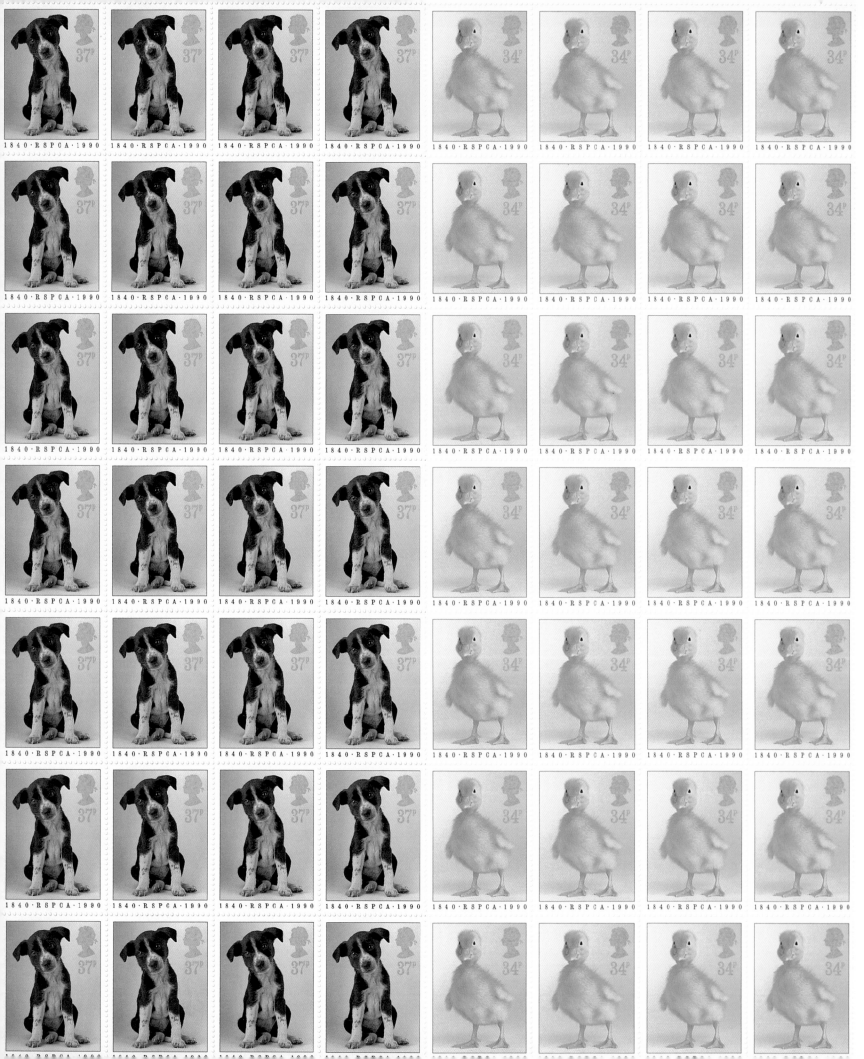

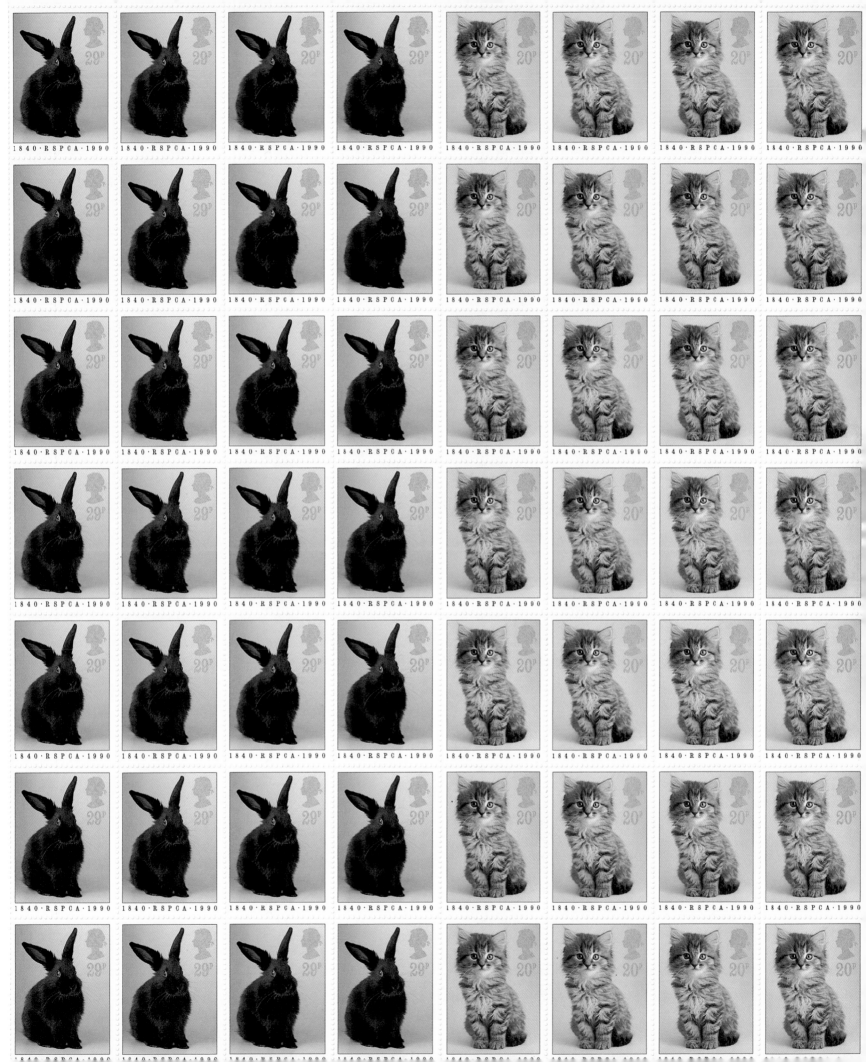

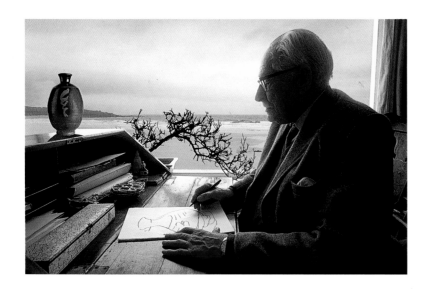

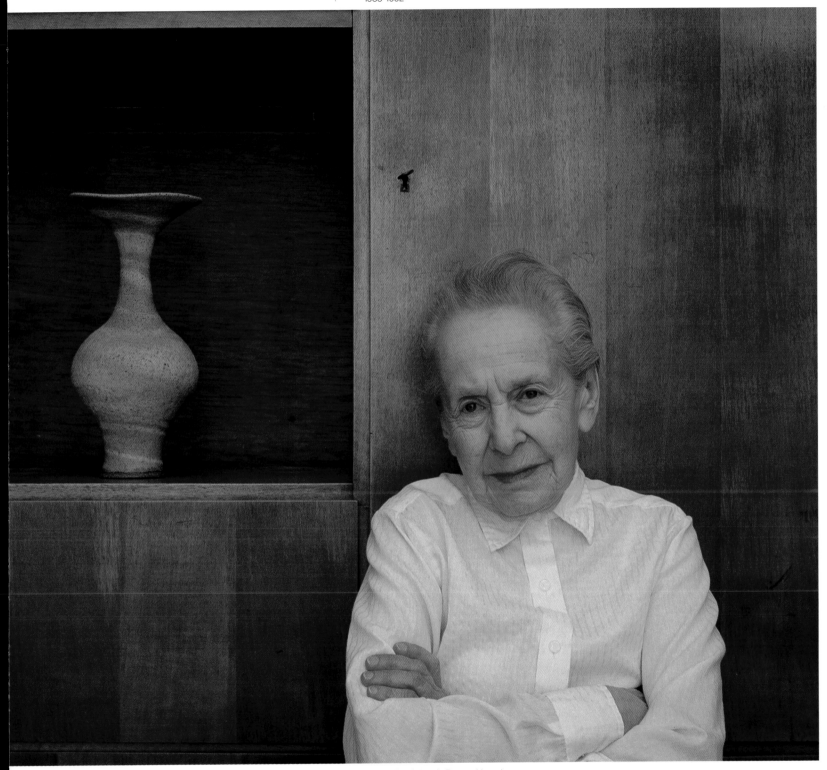

Lucie Rie (*above*), Bernard Leach
(*top left*), Elizabeth Fritsch (*middle
left*) and Hans Coper (*bottom left*)
were photographed for a series
of cards in 1988 which promoted
the special issue Studio Pottery
Post Office stamps.
1988. Hasselblad
Fujichrome

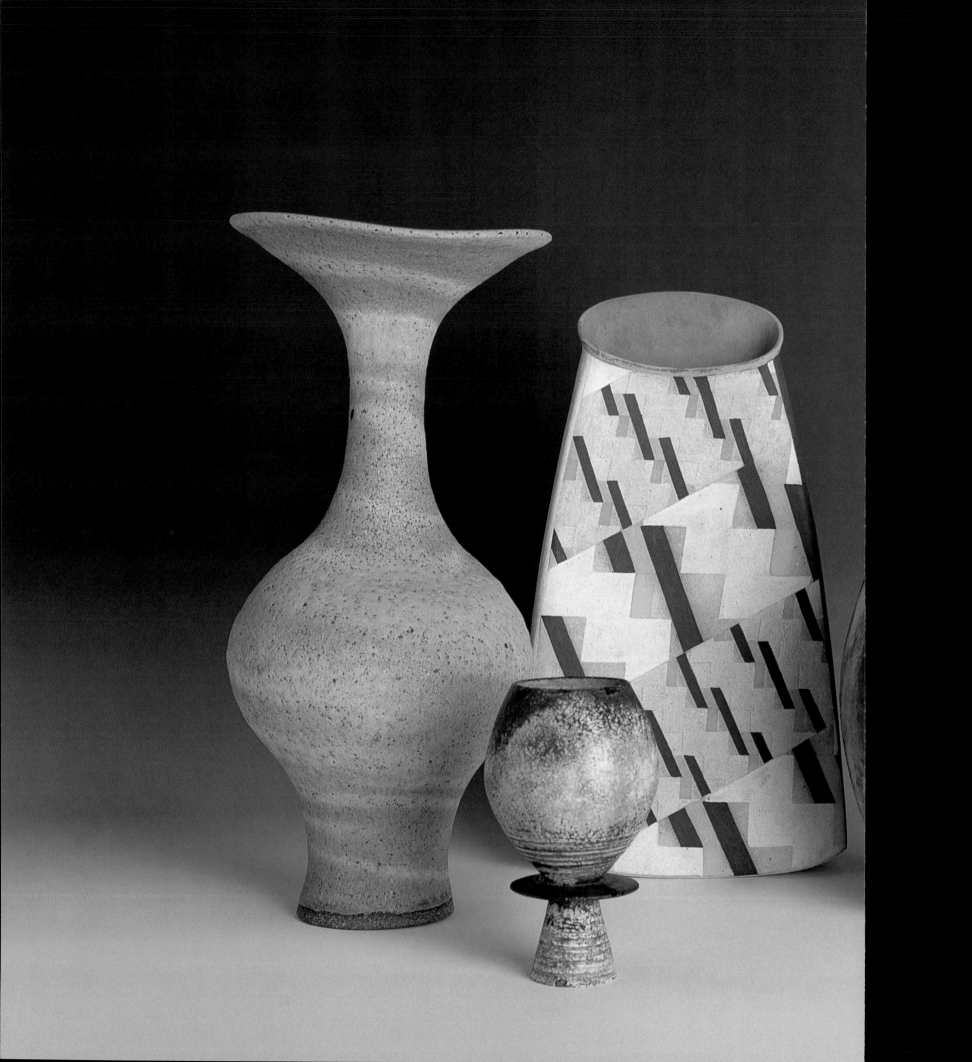

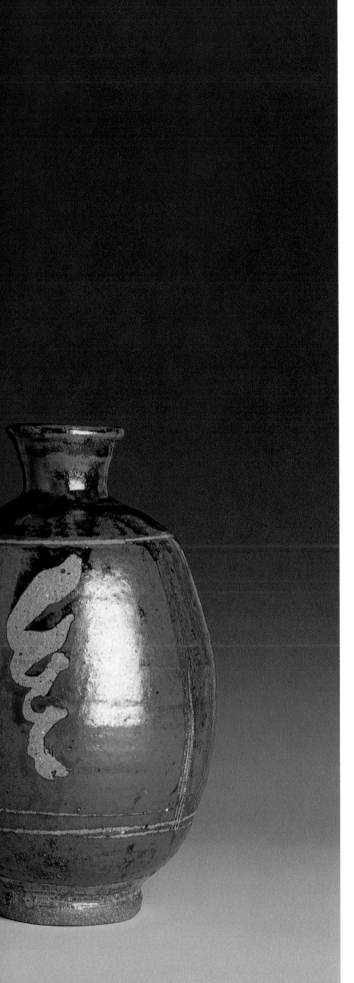

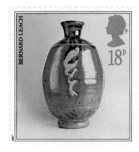

The Studio Pottery stamps were issued by the Post Office in 1987 and celebrated the work of Bernard Leach, Elizabeth Fritsch, Hans Coper and Lucie Rie. Layout and typography by John Gorham.
1986. Nikon
Fujichrome
Stamps reproduced by kind permission of The Post Office.

Peppercorns, for the *Marie France* cookery series.
1983. Nikon 55mm
Kodachrome

The cover for *Lark Rise To Candleford* by Flora Thompson, designed by Nick Thirkell and published by Century, won a D&AD Silver Nomination in 1984. The imagery was subsequently hijacked and used on a range of merchandise without the photographer's permission. Flattering, but
1982. Hasselblad
Kodak Ektachrome

Blackcurrant (*cassis*) for *Marie France*.
1983. Nikon 55mm
Kodachrome

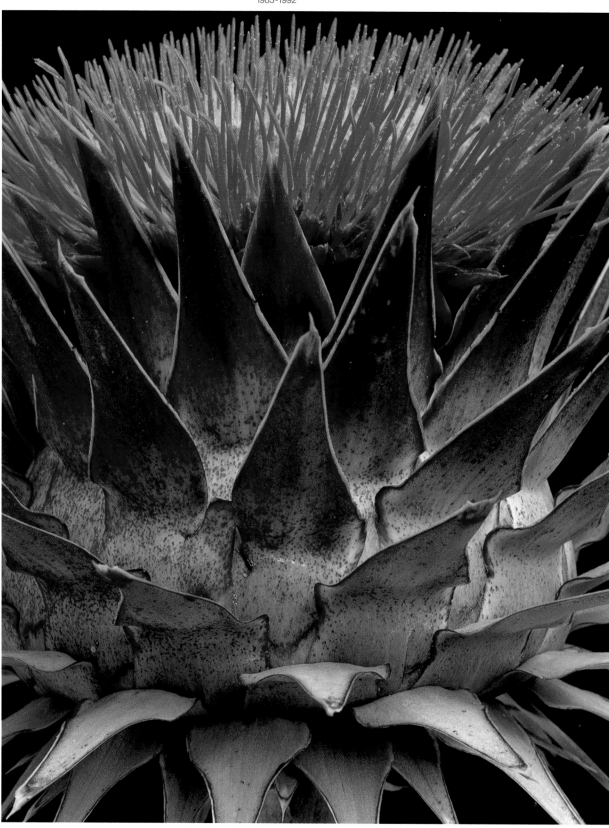

Artichoke for *Marie France*.
Art direction 'Yan D Pennor's.
1983. Nikon 55mm
Kodachrome

Right and following pages.
A carrot flower, bee's honeycomb
and Marguerite daisy, for the Blue
Circle 1985 'Nature's architecture'
corporate calendar designed by
Derek Forsyth (see also page 132).
1984. Nikon
Kodachrome

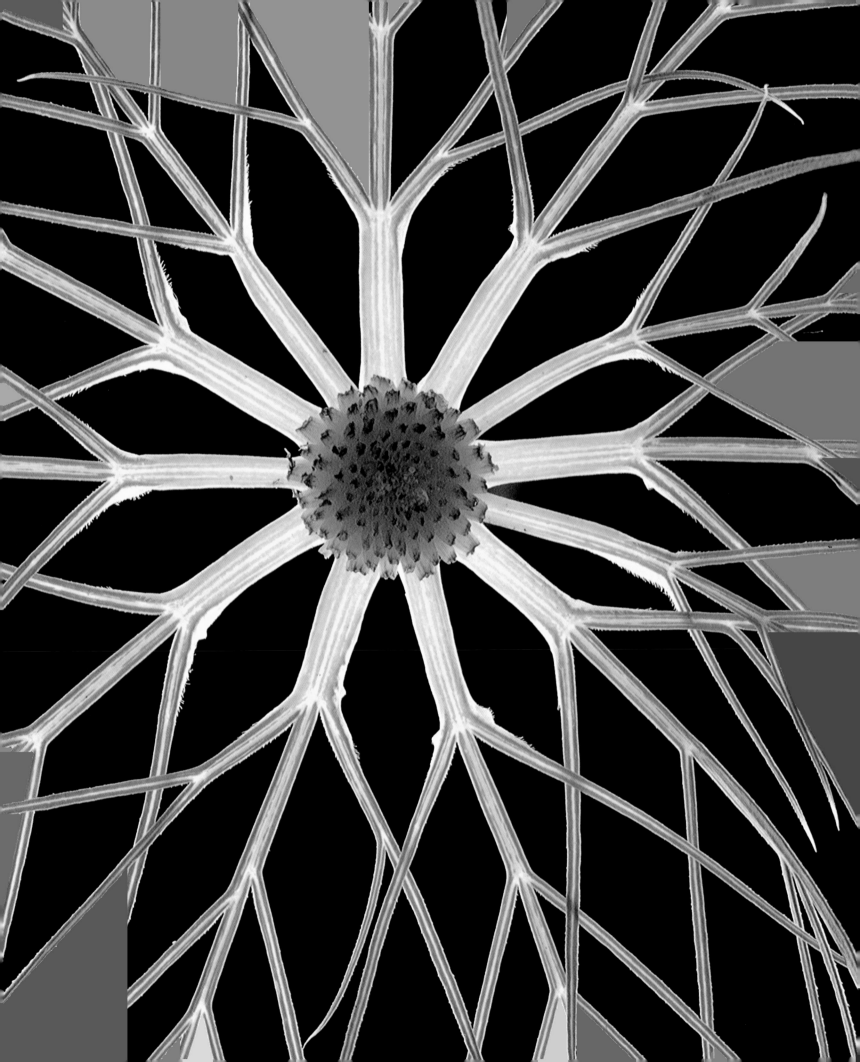

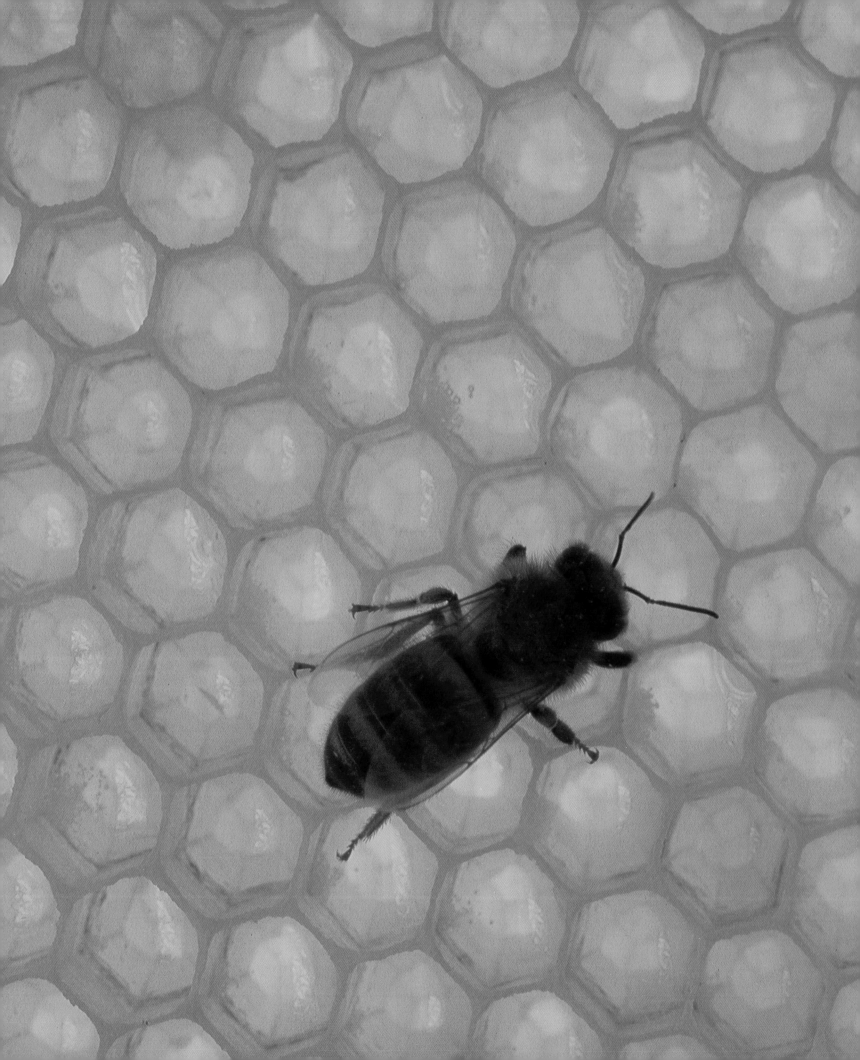

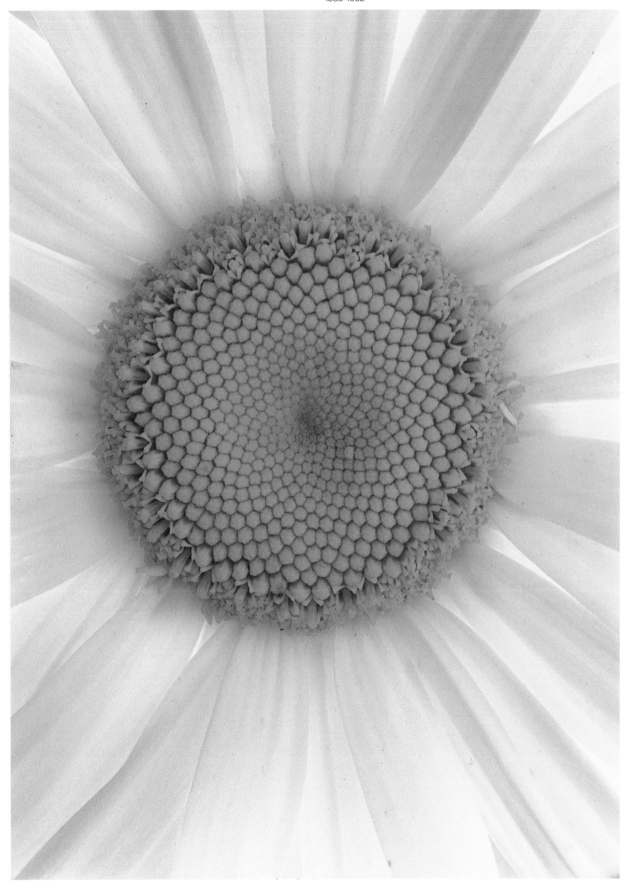

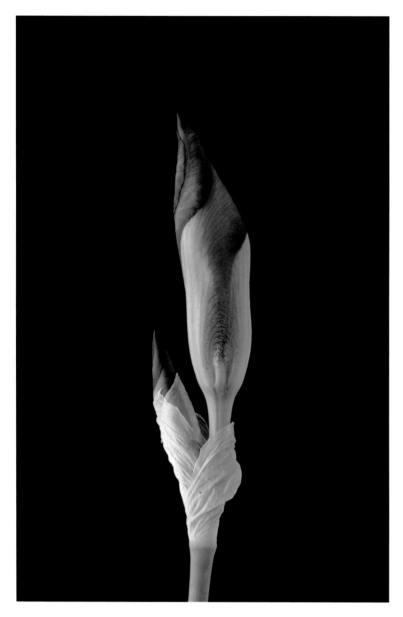

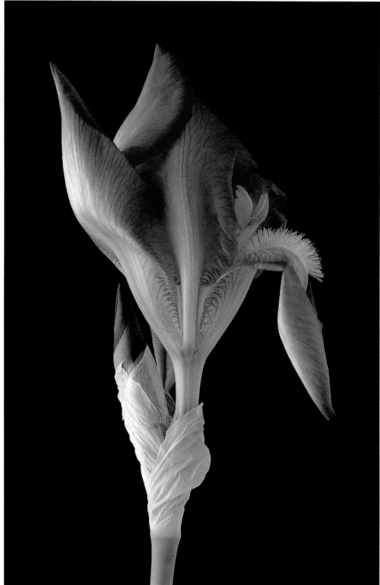

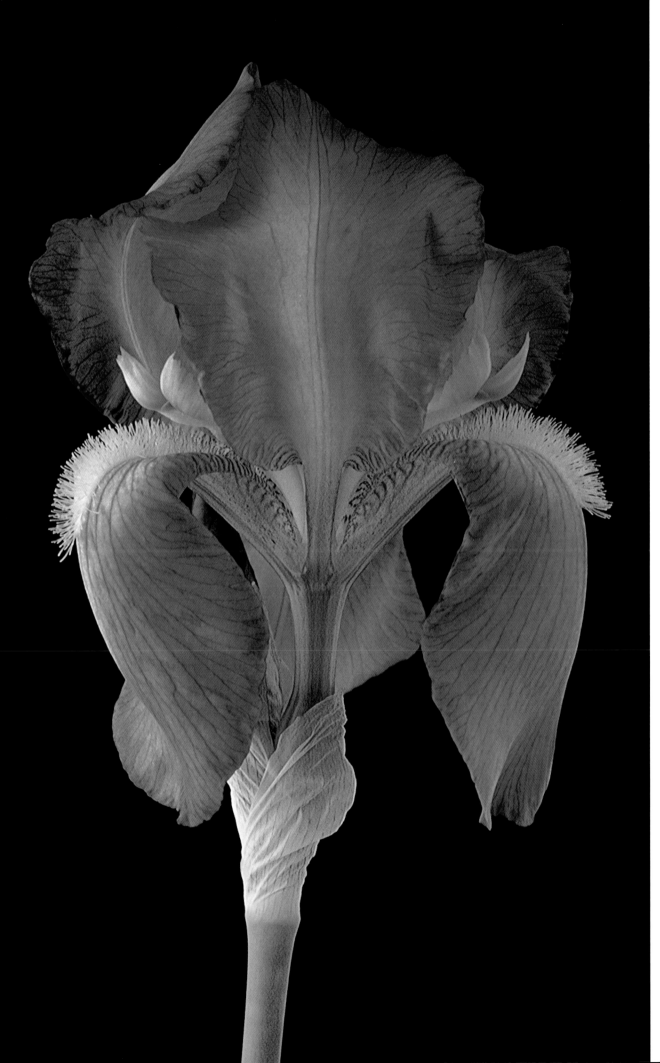

One of Evans's final projects was the assembly of a series of photographs of irises that he had been taking since 1984 into a boxed sets of prints, *Iris Flowering*, which went on sale in 1990. It was when working on *The Flowering of Britain* with Richard Mabey that he became fascinated by the ways flowers 'worked' – how they moved as they unfolded, and often going through the reverse motion when they withered. He began experimentation with a series of time-lapse images of an iris in 1984, although most of the photographs were taken in 1988 and 1989. Public purchasers of the set include the Museum of Modern Art in Houston, Texas, and the WH Smith Collection in their headquarters building in Swindon.

1984-1989. Nikon Kodachrome

Index

$\frac{N}{25^{\circ}P}$